DUE
9 NOV 99

Complete Camcorder Troubleshooting and Repair

Written by:
Joseph Desposito
and
Kevin Garabedian

PROMPT® PUBLICATIONS

©1998 by Howard W. Sams & Company

PROMPT© **Publications** is an imprint of Howard W. Sams & Company, A Bell Atlantic Company, 2647 Waterfront Parkway, E. Dr., Indianapolis, IN 46214-2041.

International Standard Book Number: 0-7906-1105-8
Library of Congress Catalog Card Number: 97-68178

Acquisitions Editor: Candace M. Hall
Editor: Loretta L. Leisure
Assistant Editors: Pat Brady, Natalie Harris
Layout Design: Loretta L. Leisure
Cover Design: Suzanne Lincoln
Graphics Conversion: Tim Clency, Nathan Bekiares, Bill Skinner, Terry Varvel
Additional Illustrations and Other Materials: Courtesy of Hitachi Home Electronics, Matsushita Electric Industrial Company Ltd., Minolta Corporation, Sharp Electronics Corporation, and Thompson Consumer Electronics.

PRINTED IN THE UNITED STATES OF AMERICA

9 8 7 6 5 4 3 2 1

Table of Contents

Preface

In this book, Kevin and I want to give you a hands-on feel for camcorder repair. Camcorders are so small that you might not want to tackle a repair for fear that you might break something. This might happen; but, don't worry. Whatever breaks can usually be fixed.

To help you understand what is involved in camcorder repair, we present a good deal of background material as well as seven real-life case studies. To our minds, there is no better way to learn camcorder repair than through case studies. With the photographs and captions used in the case studies, it is as if you are looking over the shoulder of a professional technician and listening to his thoughts throughout the repair process. This gives you invaluable experience in learning to do repairs on your own.

In this book, we have concentrated on camcorders that have been on the market for a number of years. We cover VHS, VHS-C and 8 mm camcorders in the book, but not the latest digital camcorders.

Service manual information is included in this book. However, you don't always need a service manual to complete a repair. Your powers of observation and skill at taking apart mechanical assemblies and putting them back together is usually more valuable than a service manual.

Enjoy the book. If you have any feedback for Kevin or myself, you can reach us through e-mail at jdespo@ix.netcom.com and nabatv@aol.com.

Dedications

Joseph Desposito dedicates this book to:

> My wife, Lorraine, and to Jeremy and Samantha Desposito and Scott and Samantha Streater, and to Molly, the cocker spaniel, who loves to sleep at my feet as I write.

Kevin Garabedian dedicates this book to:

> Hassan, Sheppy, Eddie, Mimo and all the other guys who stop by the store.

Chapter 1
Introduction to Camcorder Repair

A camcorder, as its name implies, has a split personality. On one hand it is a color camera; on the other hand it is a VCR. The block diagram of **Figure 1.1** demonstrates this division. If you already know how to repair VCRs, you have a great head start in learning to repair camcorders. If not, the knowledge gained in learning to repair camcorders will greatly speed your understanding of VCR repair.

Electronically, camcorders are very reliable. The main reason for this is battery power. A camcorder's 6- or 12-volt battery does not stress the electronics. There is very little heat buildup inside the case. But, make no mistake about it, camcorders do break and need repair, just like any other electronic product. So, what goes wrong?

Camcorders fail for three very good reasons. The first reason is mechanical breakdown. Camcorders have many small mechanical parts working together in harmony to record and play tapes. If just one of these parts loosens or breaks, the whole system goes out of whack.

The second reason camcorders fail is neglect. A complex mechanical system needs to be serviced every so often. This means lubrication, cleaning, and so forth. Most camcorder owners fail to do this. Eventually, neglect takes its toll and causes a mechanical failure.

The third reason camcorders fail is abuse. The abuse is usually accidental, such as dropping a camcorder on the pavement or forcing a tape in backwards. Whatever the reason, mechanical parts bend or break and electrical connections crack when a camcorder is abused.

Camcorder repair depends as much on your knowledge of what goes wrong as it depends on your knowledge of how the camcorder works. Camcorders are extremely complex electronically. Operations are controlled by one or more computer chips with embedded software. If you attempt to learn every last nuance of camcorder operation for each different camcorder model, you might find yourself with years and years of work ahead of you.

Remember, you don't have to know everything about how a camcorder works in order to repair it. Of course, it helps to have a "lay of the land" so to speak. You don't want to attempt a repair blindly. You need some tools and a clear direction of where you are headed.

As this book proceeds, you will be provided with the lay of the land and shown how to match symptoms to possible causes. Keep in mind what has been said about electronic and mechanical reliability. Think mechanical first. If you can't find a mechanical cause for the problem, then turn your attention to the electronics.

The next chapter explains all about the tools and test equipment generally needed to service camcorders.

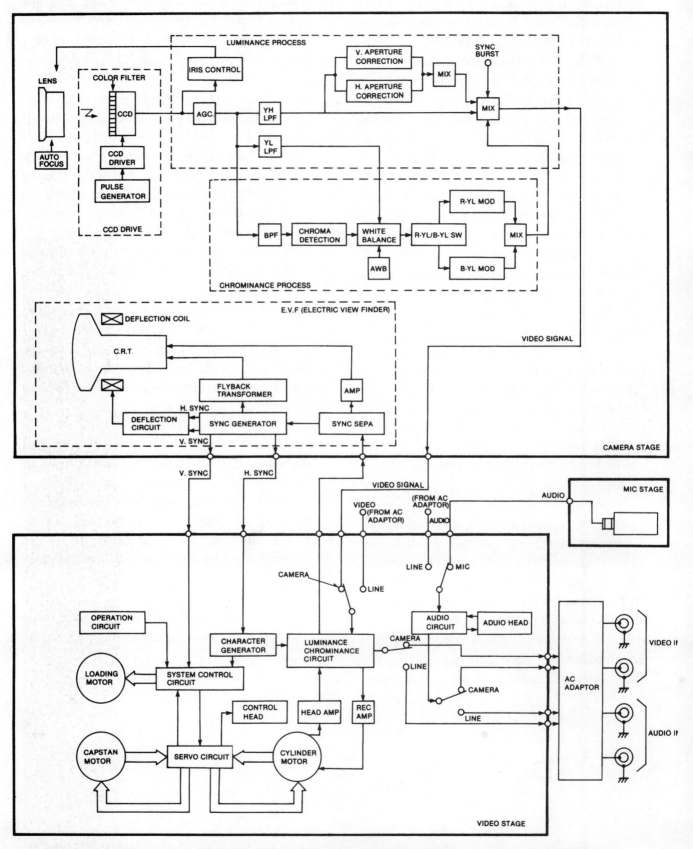

Figure 1.1. The block diagram of the Panasonic PV-300 shows the split personality of a camcorder.

Reproduced with the permission of Matsushita Electric Industrial Company Ltd.

Chapter 2

Tools and Test Equipment

To service camcorders, you will need an assortment of tools and test equipment. You may find this hard to believe, but some camcorder repairs can be completed with just a small screwdriver. But, if you want to be ready to fix all the camcorder problems that come your way, you will need to invest in some decent equipment. This chapter will give you a good idea of what is needed to do the job.

2.1 The Workbench

Before you begin to repair a camcorder (or any electronic product for that matter), you need an area where you can perform the repairs. This area should have 3-prong electrical outlets, good lighting and a magnifying lamp. If you can afford it, you may want to invest in a workbench (**Figure 2.1**). Some companies (Techni-Tool, Jensen Tools, etc.) sell special benches for electronic repair.

Figure 2.1. A workbench is a great help in organizing your repair work.

The workbench comes complete with a power strip and fluorescent lighting. Plus, there is a shelf where you can place your test equipment. This way, when you are working, your equip-

ment is not staring you in the face. It doesn't clutter your work area. These workbenches cost several hundred dollars, but are worth the investment. Of course, if you are on a budget, you can do your repairs on a simple table.

If you don't own a workbench with built-in outlets, invest in good quality power strips with surge protectors. In your work area, you will need multiple outlets to hook up test equipment, monitors, soldering irons, magnifying lamps and so forth.

Your work area needs a very good lighting system. It's very helpful to have a fluorescent light on the ceiling. You need to see what you are doing. Camcorders have very tiny mechanical parts, plus several printed circuit boards packed with tiny electronic components. Without good lighting, you will have trouble identifying parts and components. So, the better the light, the easier it will be to work.

A magnifying lamp (**Figure 2.2**) not only provides light, but also makes it easier to examine camcorder mechanisms and read component markings. When you repair a camcorder, it is often necessary to check for broken parts and cracked connections. A magnifying lamp is perfect for this job.

Figure 2.2. A magnifying lamp provides light and makes it easier to examine camcorder mechanisms and read component markings.

2.2 Tools

You will need a good set of screwdrivers, with both Phillips and flat heads. Since camcorders range in size from full to palm size, you will need a set of both regular and miniature screwdrivers. The precision screwdriver set shown in **Figure 2.3** contains Phillips head, flat head and hexagonal head drivers and is available from many parts suppliers including Radio Shack. It's best to buy magnetized screwdrivers, but this is not absolutely necessary. You can always magnetize the screwdrivers yourself by rubbing them on a heavy magnet. An old speaker is a good source for such a magnet.

A long-nose pliers is needed to remove any broken mechanical parts from the camcorder mechanism (**Figure 2.4**). These are also useful for disconnecting cables and removing belts.

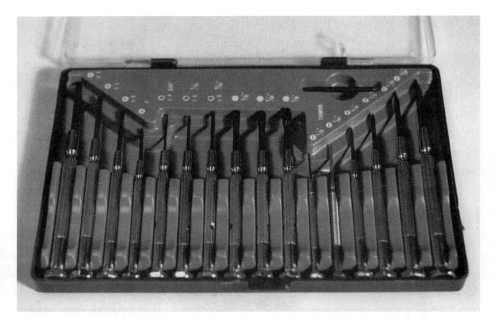

Figure 2.3. A precision screwdriver set is necessary for disassembling camcorders.

Figure 2.4. A long-nose pliers is needed to remove any broken mechanical parts from the camcorder mechanism and are also useful for disconnecting cables and removing belts.

Wire cutters are, of course, useful for cutting and stripping wires. You may not need to cut the camcorder wires, but you may want to solder a wire temporarily to a test point. Wire cutters are also useful for a non-conventional purpose. Camcorder screws are very tiny and sometimes cannot be loosened with a precision screwdriver. If you have this problem, one solution is to use a wire cutter to "bite" into the screw head (**Figure 2.5**). Twisting the wire cutter will loosen the screw.

For electrical repair work, you will need a couple of good quality soldering irons, solder wick, and a solder sucker. One of the soldering irons should be about 25 W to 35 W, while the other should be about 10 W. Both irons should have a holder that sits on the workbench. Soldering iron tips are important, too. When dealing with the surface mount components in most camcorders, you will need a tip with a fine point (**Figure 2.6**).

Figure 2.5. An unusual use for a wire cutter is to "bite" into a screw head that is too tight to remove with a small screwdriver.

Figure 2.6. When soldering and desoldering surface mount components in most camcorders, you will need a tip with a fine point.

To remove defective components, including ICs (integrated circuits), from the printed circuit board, you will need either solder wick or a solder sucker. To use solder wick, you place the metal braid over the solder you want to remove. Then, you heat the braid with your soldering iron. As the solder melts, the braid absorbs the solder. A solder sucker uses vacuum action to suck up melted solder. First, you set the pump by pushing down on a spring-loaded lever. With the soldering iron in one hand and the solder sucker in the other, you simply wait until the solder melts, place the solder sucker against the solder and release the lever. If the solder is not sucked up completely, just reload the pump and try again.

You will need solder. For camcorder work, purchase solder with .031" thickness. This allows you to solder in small areas. In other words, you can perform the repair without creating solder bridges all over the place.

You'll need specialized tools, such as curved-end tools, for grabbing and removing belts in full-size VHS camcorders (**Figure 2.7**) and tweezers for helping in the removal of sur-

face mount components. Another useful device is an alignment tool (**Figure 2.8**). This tool is used to adjust the height of tape guides. We'll show you how this adjustment is done later on in the book.

A test jig is a help when trying to spot a problem with the mechanism. This device is a clear plastic cassette that "tricks" the camcorder electronics into operating as if a cassette tape had just been placed in the machine. We use a test jig in camcorders that accept standard size VHS tapes. Test jigs are also available in the VHS-C and 8 mm formats. However, a test jig is not absolutely necessary to "fool" the camcorder. Instead, we usually cover the end LED with a rubber tube. If you don't know what an end LED is, you will find out in a later chapter on camcorder sensors.

2.3 General Test Equipment

In this section, general equipment for repairing camcorders is highlighted. Some equipment, such as a DMM, is an absolute necessity for the test bench. Other equipment, such as a transistor tester, is useful but not impera-

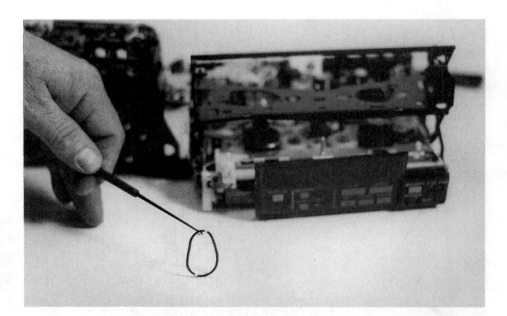

Figure 2.7. A curved-end tool is useful for grabbing and removing belts in full-size VHS camcorders.

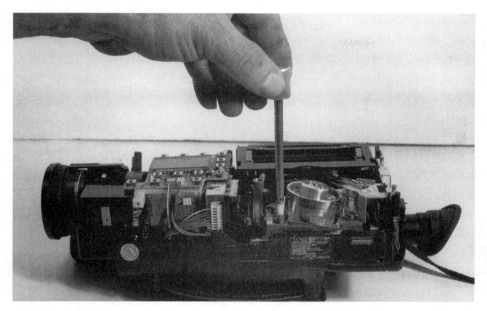

Figure 2.8. An alignment tool is useful for adjusting the height of tape guides.

tive to have. In any case, the more equipment you have, the more prepared you will be to troubleshoot all kinds of camcorder problems.

Digital Multimeter (DMM)

To service camcorders, you will need a good quality DMM. A DMM is used primarily to measure voltage and resistance. Most modern DMMs have a diode setting, marked with a diode symbol (**Figure 2.9**). This setting is used for checking all of the solid-state devices in

the camcorder, including ICs, diodes, transistors and so forth. If you have an older meter, you may not have the diode setting. If this is the case, you may want to consider purchasing a new DMM.

Oscilloscope

An oscilloscope is always a useful addition to the workbench. An analog scope with a 60 megahertz (MHz) bandwidth will serve you well.

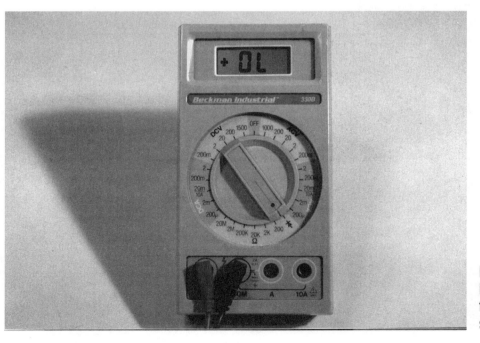

Figure 2.9. Most modern DMMs have a diode setting, marked with a diode symbol.

Don't get the idea that you'll need an oscilloscope for every repair. It is only needed every so often. For example, you may have a camcorder whose camera part is not functioning. Without an oscilloscope you cannot check for waveforms at various test points in the camcorder. A scope will show you if a particular component, such as the CCD, is producing a signal, even if the viewfinder does not display it.

Transistor Tester

A transistor tester does a more thorough job of checking transistors than you can do with just a DMM. The transistor tester we use (**Figure 2.10**) is the model 520B made by B&K Precision Instruments. This industrial type tester has three leads. You hook up these leads to the three leads of the transistor.

On the right side of the meter is a multiposition switch. You turn this knob until you get the right setting for the collector, base and emitter. At the left, a light comes on and tells you if the transistor is silicon or germanium. Another 2-position switch lets you know if the transistor is leaky. You turn the switch to the right and the meter indicates the extent of the leakage. This tester can also measure diodes.

A transistor tester is a very easy and fast way of checking transistors, but unfortunately this instrument is expensive, costing about $500.

Power Supply

A bench-type power supply (**Figure 2.11**) is an absolute necessity for camcorder repair. Remember, camcorders are battery-powered devices, so you cannot just plug them into an AC socket. If a customer forgets to bring an AC adapter or a battery, or if the battery weakens during testing, you will have no way to check out the camcorder.

We use a B&K Precision Instruments Model 1601, which is a regulated power supply. It has a voltage range from 0 to 50 V on two ranges, 0 to 25 V and 0 to 50 V. To power a camcorder during servicing, you simply clip the leads of the power supply to the battery terminals of the camcorder. Full-size VHS camcorders typically need 12 VDC, while 8 mm and VHS-C camcorders operate at 6 VDC.

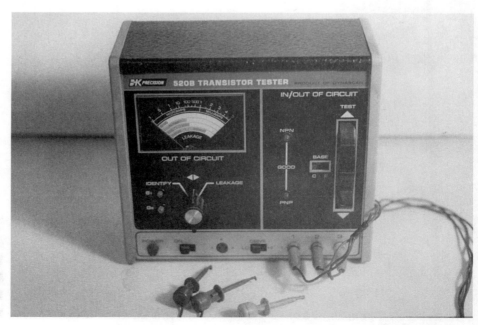

Figure 2.10. The transistor tester we use is the model 520B made by B&K Precision Instruments.

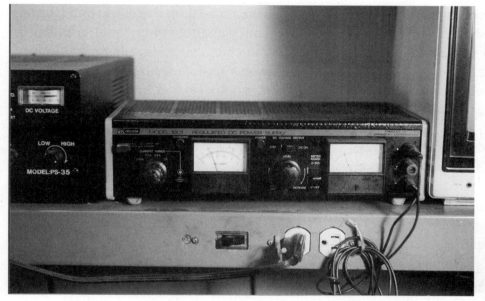

Figure 2.11. A bench type power supply is an absolute necessity for camcorder repair.

This particular B & K power supply has current limiting capabilities. This is a switch that you can set up to block current. This allows the power supply to cut off the power if you are afraid that the supply will damage some part. You can set the current to a lower rating. There are four ranges: 0.05, 0.2, 0.5 and 2 A.

A power supply can be used, for example, to energize the loading motor of a camcorder (**Figure 2.12**). Many camcorder problems are mechanical in nature. At some point in the dis-

assembly of the camcorder, you may have only the mechanism in front of you. To test the operation of the mechanism, you simply apply 3 volts DC to the leads of the loading motor. If nothing happens, switch the leads. Applying voltage one way makes the mechanism move in one direction; applying the voltage the opposite way makes the mechanism move in the opposite direction. One caution here: the main PC board must be disconnected from the mechanism before you try this. If not, you can easily blow out the motor driver IC.

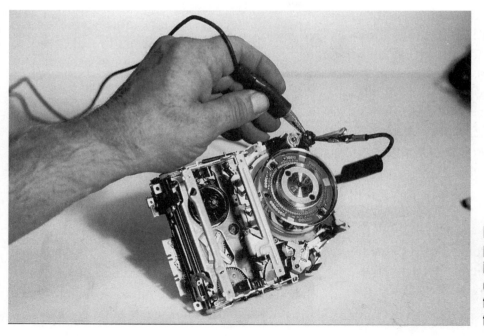

Figure 2.12. A power supply is useful for energizing the loading motor of a camcorder and putting the mechanism into motion.

There is a wide range of regulated bench supplies on the market. You should look for a supply with at least 15 volts and 2 amps voltage and current capability.

Composite Video Analog Monitor

All camcorders come complete with a display device, either a tiny CRT (cathode ray tube) or an LCD (liquid crystal display) panel. Sometimes, when servicing a camcorder, looking in the viewfinder or at the display panel is the only way to tell if the unit is working. However, if the camcorder has RCA jack video and audio outputs, it is a better idea to connect the camcorder output to a composite video analog monitor. Then, as you work on the repair, you can check the video and audio.

Some camcorders have proprietary cables for video and audio outputs. If the owner of the camcorder forgets to bring the cables to the shop, you have no other choice than to use the display provided by the camcorder.

2.4 Specialized Test Equipment

Test Tape

Test tapes are valuable for doing alignments, for example, if a tape guide has loosened and must be readjusted. You'll need three different test tapes for standard VHS, VHS-C and 8 mm. If you don't want to invest in test tapes, an alternative is to record material with a known good camcorder or VCR in the appropriate format. For example, instead of purchasing an 8 mm test tape, we record 8 mm tapes using a Sony EV-A50 8 mm VCR.

Personal Computer

You may have never thought of a personal computer as "test equipment," but a notebook PC is recommended by some camcorder manufacturers for servicing their equipment.

If you are an authorized dealer for a particular manufacturer, you may want to invest in their computer diagnostic equipment. **Figure 2.13** shows how a notebook computer is used to perform diagnostics on a Minolta Master 8-418 camcorder.

Vectorscope

Camcorder service manuals usually include a large number of electrical tests and adjustments. For some of these, a vectorscope is needed. This is a very expensive test instrument that provides an unusual display (**Figure 2.14**). Its purpose is to measure chroma/burst phasing and color saturation. We do not use a vectorscope in our shop for the simple reason that for the majority of repairs this instrument is not needed.

2.5 Miscellaneous

There are many accessories that make camcorder repair work easier to do. Jumper cables, video and audio patch cords and chemicals are just a few.

Jumper cables are very handy. Sometimes during a repair, you have to connect a wire to a test point or bridge a capacitor that you suspect is defective. Jumper cables make it easy to do this. Or, you may want to make a solid connection to ground for your measurements. You can connect one end of a jumper cable to the grounding point and the other end to the test probe. There are many kinds of jumper cables. Some have alligator clips, which are good for attaching to larger areas, such as test points and ground planes. Some have spring-loaded hooks, which are good for tight spots such as the leads of transistors or ICs. Spring-loaded hooks help to avoid creating shorts between component leads.

You will need video and audio patch cords with RCA plugs on each end. As just de-

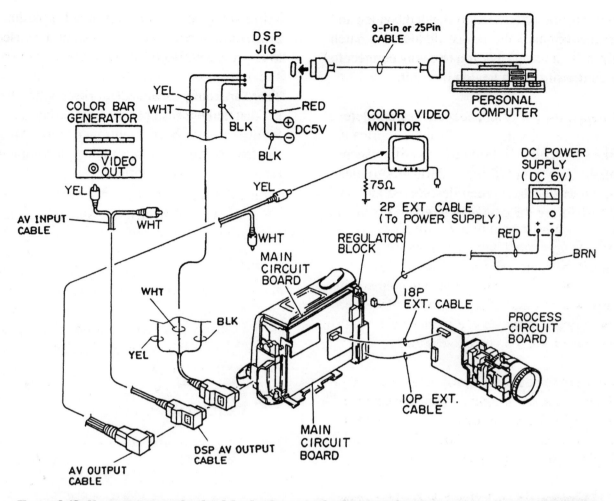

Figure 2.13. If you are an authorized dealer for a particular manufacturer, you may want to invest in their computer diagnostic equipment. *Reproduced with the permission of Thompson Consumer Electronics.*

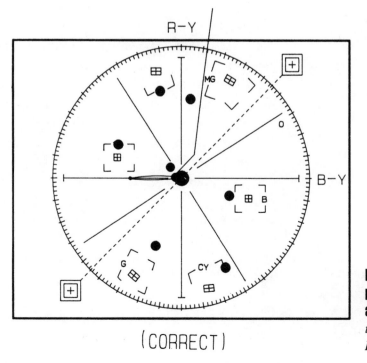

(CORRECT)

Figure 2.14. A vectorscope is a very expensive test instrument that provides an unusual display. *Reproduced with the permission of Thompson Consumer Electronics.*

scribed, you often need to check the video and audio outputs of the camcorder. Having patch cords on hand allows you to easily connect to a composite video analog monitor.

Chemicals are often needed to complete a camcorder repair. You will need lubricants, like a light oil, to lubricate parts of the mechanism. Plus, you will need defluxers to clean up areas that have been desoldered and soldered during the course of a repair. Defluxers help dissolve and remove flux residue. A small brush (a toothbrush is perfect) should be used to apply the defluxer.

There are many other accessories on the market that make it easier to do repairs. Just a few favorites have been mentioned here. Most electronics parts catalogs include a complete range of repair accessories.

Chapter 3

Camcorder Types and Safety Procedures

3.1 Camcorder Types

There are three general types of camcorders: standard VHS, VHS-C and 8 mm. All of these use different kinds of tape. Within the 8 mm format are the standard 8 mm and Hi 8, which use the same kind of tape.

A standard VHS camcorder uses standard size ½" VHS tapes. These are the tapes everyone is familiar with since they are also used in VHS VCRs. A VHS-C camcorder uses a ½" VHS-C tape. This tape is a reduced size version of a standard VHS tape. You can play this tape in a standard VCR by placing the VHS-C tape in a special adapter. An 8 mm camcorder uses an 8 mm tape, which only can be played in 8 mm and Hi 8 camcorders and VCRs.

The three systems are different both mechanically and electrically. In later chapters, these differences will be covered. As far as servicing goes, however, you should always have several tapes of each format on hand for testing purposes.

3.2 Safety Procedures

Camcorders are relatively safe to work on compared to some other electronics products such as televisions. Camcorders work on battery power for the most part, so there are no high voltages to worry about. Also, camcorder components are small. A fully charged capacitor that would pack a wallop if you touched it in a TV, does not have the same power in a camcorder.

The one place where high-voltage exists in most camcorders is in the viewfinder. Viewfinders contain a tiny CRT, which needs a high voltage to work, just like a regular-size CRT. However, this small CRT is not accessible unless you disassemble the viewfinder (**Figure 3.1**). Camcorders with LCD panels only do not need the high voltages required by a CRT.

Larger camcorders and any camcorder connected to the AC line present more danger to the technician. If you work with a camcorder

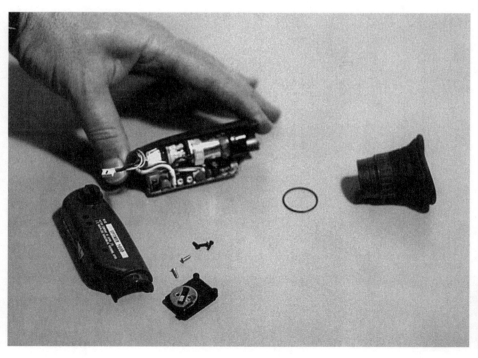

Figure 3.1. The small CRT in a camcorder is not accessible unless you disassemble the viewfinder.

connected though an AC adapter to the AC line, it is smart to use an isolation transformer, just as you would when servicing a TV or other AC-powered electronics.

The most dangerous item you might attempt to repair is the camcorder's AC adapter. In our experience, though, customers *never* bring in their AC adapters for repair. Either these adapters are exceptionally reliable or the customer sees this component as separate from the rest of the camcorder and will replace it, if necessary. Obviously, the cost of an AC adapter is much less than the cost of the camcorder and it makes more sense to buy a new one than to fix the old one.

Chapter 4

Making Measurements

An important part of the repair process is making measurements of voltage and resistance. The results tell you what is wrong with the camcorder—if you have made the measurements correctly. This chapter covers the techniques you need to know to make proper voltage and resistance measurements with a digital multimeter or DMM.

4.1 Making Voltage Measurements

Voltages are measured in parallel with the circuit you are checking. That is, you place the positive lead of the DMM at the point to be measured and the negative lead at a ground point. Most voltage measurements are made from the foil side of the printed circuit board rather than the component side (**Figure 4.1**).

Current, on the other hand, is measured in series. In other words, in order to measure the current you have to disconnect some component from the circuit. Instead of that component, you place the DMM in series in the circuit where you want to measure the current. To measure voltages, you don't have to disconnect anything. For the most part, you will *not* be making current measurements. Most of the measurements you make will be voltage and resistance measurements. If you have the schematic diagram of the camcorder, you can make comparative measurements very easily. For example, you can check a particular pin of an IC or the collector, base, or emitter of a transistor to find out if the voltages at these points are correct.

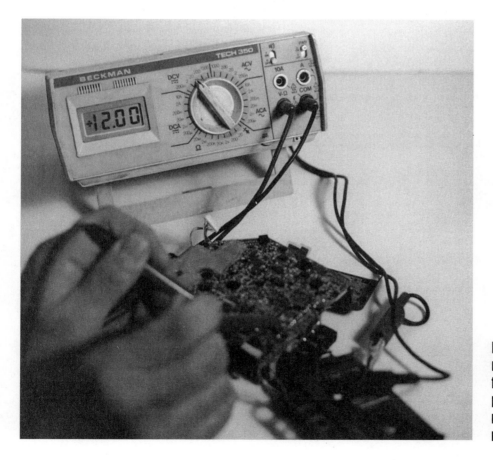

Figure 4.1. Most voltage measurements are made from the foil side of the printed circuit board rather than the component side.

4.2 Resistance Measurements

Resistance measurements can be made in-circuit and out-of-circuit. In-circuit resistance measurements should be made only after the camcorder is disconnected from the power source. Resistance measurements are made in parallel with the component you are measuring. In other words, you place the DMM leads across the leads of the component.

Like voltage measurements, resistance measurements are most easily made on the foil side of the printed circuit board. When you measure a resistance in-circuit, you may not be measuring the actual resistance of the component. If you really want the actual resistance, you have to disconnect one lead of the component from the circuit and then measure the resistance. Let's say you measure the resistance of a transistor in-circuit. If you get suspicious that the resistance is very low, then you should disconnect the leads of the part and measure it out of the circuit.

Resistance measurements, as you can see, are not meant only for resistors. You can check the resistance of diodes and ICs, too. In fact, measuring the resistance of solid-state devices such as those just mentioned is an excellent way of checking if there are any shorts in the circuit. For example, measuring resistance between two pins of an integrated circuit tells little except whether the IC has a dead short or not. This is all you can measure because ICs are complex devices containing resistors and transistors. Basically, you are looking for a short (zero or very low resistance), you are not looking to measure the resistance. Whenever you make resistance measurements on solid-state devices, the DMM should be placed in the diode resistance measurement mode (**Figure 4.2**).

Diodes are fairly easy to check with a DMM set to the diode mode. Depending on the diode, one measurement should be about 500 ohms. This measurement is made with the negative lead of the DMM on the cathode of the diode and the positive lead of the DMM on the anode (**Figure 4.3a**). The other measurement should show an infinite resistance. This measurement is the reverse of the previous one (**Figure 4.3b**).

Figure 4.2. Whenever you make resistance measurements on solid-state devices, the DMM should be placed in the diode resistance measurement mode.

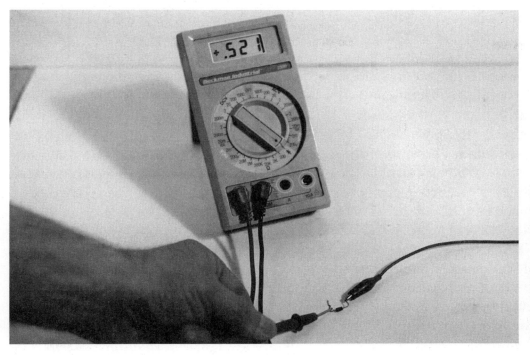

Figure 4.3a. Measuring the forward resistance of a diode. The reading on the DMM shows the proper resistance for this measurement.

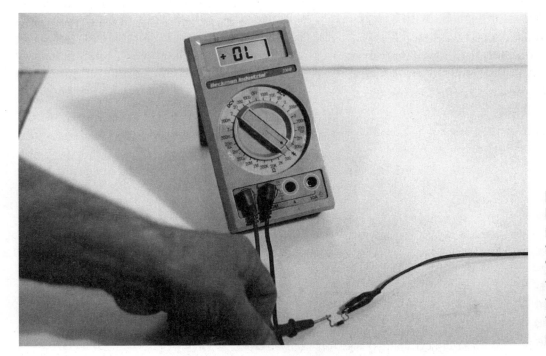

Figure 4.3b. Measuring the reverse resistance of a diode. The reading on the DMM shows the proper resistance for this measurement.

In general, diodes are easy to check. Most of the time, you can make the measurement in-circuit. However, if there are any components in parallel with the diode, you should disconnect one side of the diode before making the measurement. A bad diode may be shorted (low resistance in both directions) or open (infinite resistance in both directions).

Transistors can be checked with the DMM set to the diode setting. You can make the measurement either in-circuit or out-of-circuit. If you get a reading that is not acceptable, then you should desolder the transistor from the printed circuit board and take it out of the circuit. Then, you can measure it either with a

DMM in the diode mode or with a transistor tester such as the one described in Chapter 2.

With the DMM, you measure the resistance between the base and the collector and between the base and emitter of the transistor (**Figure 4.4**). You cannot reliably measure between collector and emitter because of the nature of the transistor. A bipolar transistor is like two diodes placed together. When you measure between the base and emitter in one direction, you will get a reading like a regular diode—about 500 ohms. If you reverse the leads, the DMM will measure infinite resistance. The same will occur between the base and collector. A bad transistor, like a bad diode, will measure either a short or open in both directions.

Sometimes, a transistor has a built-in bias resistor between the base and emitter. This will cause you to get a low reading of approximately 160 to 180 ohms, due to the resistor that is there. If you suspect this is the case,

you must check out the part in a reference book such as the *ECG Semiconductors Master Replacement Guide* from Philips ECG. This cross-reference manual will tell you if a transistor has a built-in resistor. Also, the schematic of the camcorder sometimes shows this built-in bias resistor. If the transistor does not have a built-in resistor for a bias yet still has a low reading, the transistor is leaky and has to be replaced.

As mentioned, you can check ICs (with a DMM on the diode setting) only for a short. You cannot check if the IC is good or bad because of the complexity of the integrated circuit. You can check for a short, for example, between the supply voltage (Vcc) and ground pins. Most ICs have a built-in regulator at the Vcc pin. If there is a short, you can be fairly certain the IC is bad. The opposite is not true, however. If there is no short, you cannot be certain that the IC is good. A reliable way of checking integrated circuits with common test equipment doesn't exist.

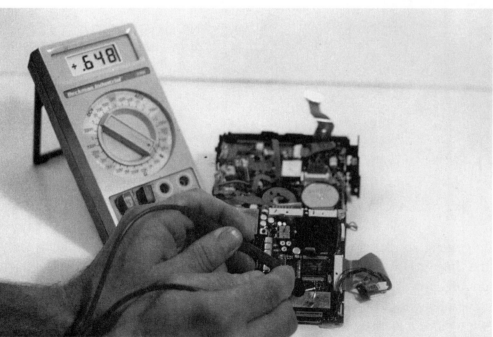

Figure 4.4. Measuring the forward resistance between the base and the collector of a transistor with a DMM. The reading on the DMM shows the proper resistance for this measurement.

If you measure a short between the Vcc and ground, then you should disconnect the pin of the IC from the printed circuit board. You can do this by desoldering the pin with a solder wick until all solder is removed from the pin. You do not have to remove the IC from the PC board. Simply make sure that the one pin in question (Vcc) is completely disconnected from the PC board. Once this is done, you have to make the measurement again. If you measure a short again, the IC is bad and has to be replaced.

Shorts in ICs do not always occur between Vcc and ground. On some ICs, the short may occur between the Vcc and the output. Again, you can check the two pins for a dead short but nothing else.

Chapter 5

Practical Repair

Repairing a camcorder is not just a matter of finding the source of the problem and replacing the defective part. Any repair starts with disassembly of the camcorder. You may think this simply means removing the cassette cover of the camcorder. This could not be further from the truth. To perform most repairs, major disassembly is required. This chapter covers the steps typically needed—over and above the troubleshooting process—to complete the repair.

5.1 Disassembly & Re-assembly

The disassembly needed to arrive at the point where you can start fixing a problem varies from camcorder to camcorder. If you are lucky, the camcorder's problem will be with the upper mechanism. This requires the least disassembly. If the problem lies anywhere else, you essentially have to take the entire camera apart. And, if you are doing an electrical repair, you may have to remove the mechanism completely and then reassemble the electronics before you can even begin your testing!

We will cover one disassembly scenario in detail to give you a good idea of what is involved. The JVC GR-AX7U is a palm-sized VHS-C camcorder (**Figure 5.1**). In order to work on the electronics, you have to disassemble the entire camcorder. A precision Phillips magnetized screwdriver is a very handy tool for this job.

As you remove the right and left sides of the enclosure, you have to disconnect several cables. If you are performing the disassembly without a service manual, you need either an excellent memory or some other aid to remember where each cable connects. One good way to keep track of the cables is to place adhesive labels

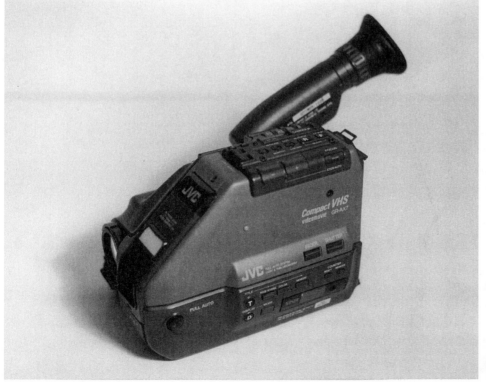

Figure 5.1. The JVC GR-AX7U camcorder.

around them. In this camcorder, the connectors have names such as CN1. Write the name of the connector on the label so that you know where it goes when you re-assemble the camcorder.

We'll go through the various stages of disassembly of the JVC GR-AX7U using figures from the service manual. The actual repair of this camera is detailed in Appendix A: Case Study 1. As we go through the disassembly, make note of the names of the various parts. You'll realize after a while that to be successful in camcorder repair, you need a clear understanding of the various parts of the camcorder and how they interact.

Figure 5.2 shows the first step in the disassembly of the JVC GR-AX7U. You need to remove four screws and lift off the operation unit. Not shown in the figure is a cable that connects the operation unit to the main (VTR) PC board. In this

camcorder, there are two kinds of cables, wire and flat flexible cables. To remove a flat flexible cable, you must first pull out the top edge of the connector with a small flat-edge screwdriver (**Figure 5.3**). This releases the pressure on the cable and allows you to pull it out. During re-assembly, you must first seat the cable properly in the connector and then push the top edge into place. This locks the cable in place.

The next piece to remove is the electronic viewfinder (**Figure 5.4**). Remove two screws and disconnect cable 1. The hood and front panel assemblies come off next (**Figure 5.5**). Here, four screws and two connectors must be removed. The front panel assembly contains the microphone, white balance sensor, and red recording LED.

Unlike some other camcorders, this camcorder does not have a separate door covering the cassette housing assembly.

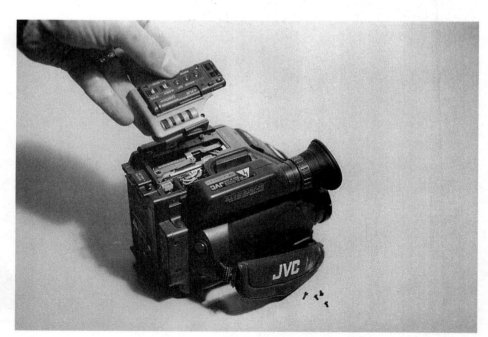

Figure 5.2. Lifting off the operation unit of the JVC GR-AX7U camcorder.

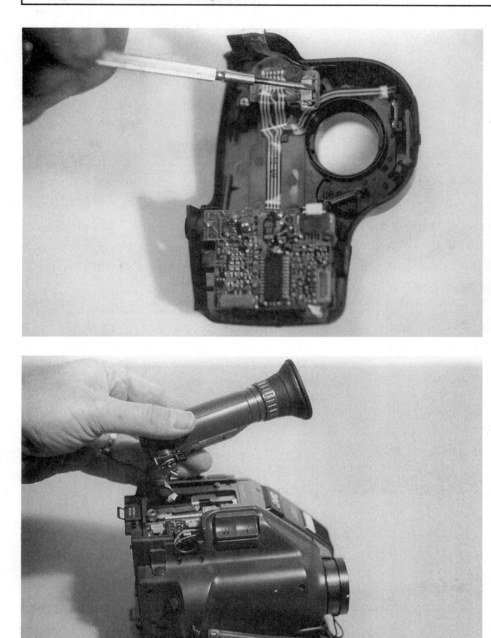

Figure 5.3. A connector for a flat ribbon cable should be pushed open with a small flathead screwdriver before removing or replacing the cable.

Figure 5.4. Removing the electronic viewfinder.

The cassette cover is actually the whole left side of the camera (**Figure 5.6**). Two screws must be removed and a flat cable released from its connector.

The upper cover assembly (**Figure 5.7**) comes off next by removing two screws and a connector. This piece covers the drum assembly of the camcorder. The rear cover assembly comes off by removing four screws and a connector (**Figure 5.8**). Keep in mind that the rear cover contains the battery terminals. If you want to make electrical measurements at a later time, you have to reconnect this cover and apply power to the terminals.

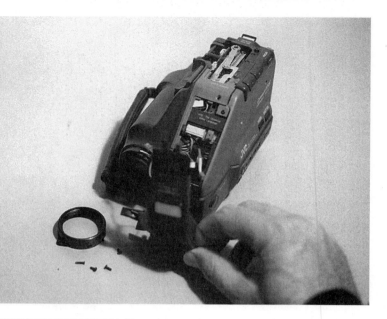

Figure 5.5. Removing the hood and front panel assemblies.

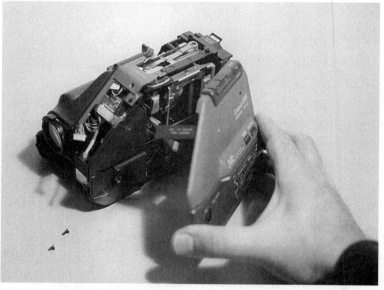

Figure 5.6. Removing the cassette cover.

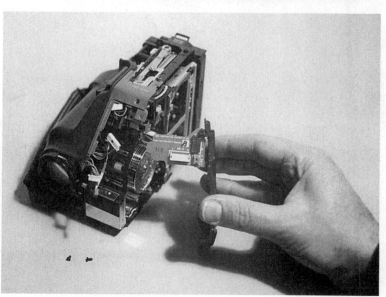

Figure 5.7. Removing the upper cover assembly.

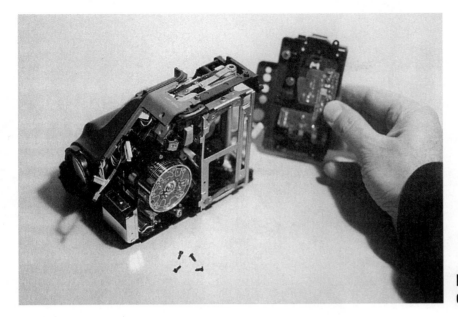

Figure 5.8. Removing the rear cover assembly.

By removing five more screws and two cables (**Figure 5.9**) you can take off the lower case assembly. Notice, you get to two of the screws through the cassette housing assembly. The lower case assembly doesn't slide off easily. You have to jiggle and pull and twist to remove it. It is also tricky to seat the main body properly in the lower case assembly when you are putting the camcorder together.

With the case now completely removed, you can remove the camera section from the deck section (**Figure 5.10**) by pulling in the direction of the arrow and disconnecting connectors 1 and 2. You also have to disconnect cables 3, 4, and 5. It's not easy to see in this figure, but there is a large PC board attached to the back of the cassette mechanism.

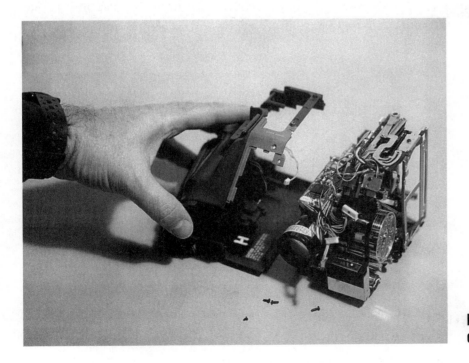

Figure 5.9. Removing the lower case assembly.

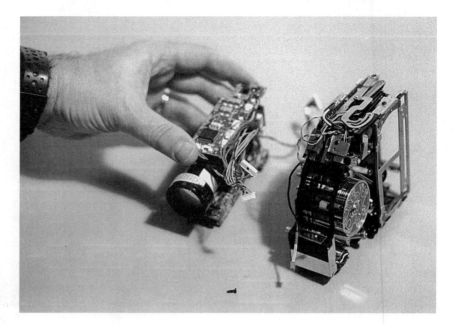

Figure 5.10. Removing the camera section from the deck section.

This large PC board, the VTR board, is removed by unscrewing two screws that hold it to the cassette mechanism (**Figure 5.11**).

The final disassembly steps we will cover here are the removal of two small circuit boards that surround the lens. There are no more screws to worry about, only connectors. **Figure 5.12** shows the removal of the video board, while **Figure 5.13** shows how the DC-DC converter comes off. To

give you a better idea of how small these circuit boards are, we took of photo of the DC-DC converter board lying next to a standard size pen (**Figure 5.14**).

Disassembly can continue even further, but we won't go into it here. We will say, though, that to troubleshoot the electronics of this camera, you now have to go back and connect the camera section to the VTR board. Then, you have to re-connect the rear cover assembly to provide power and

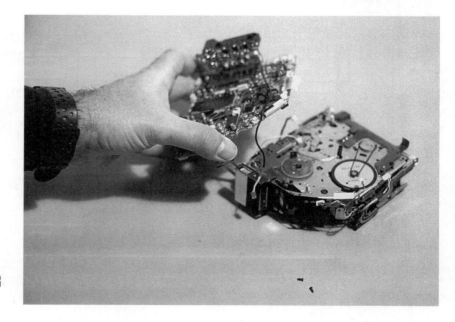

Figure 5.11. Removing the VTR board.

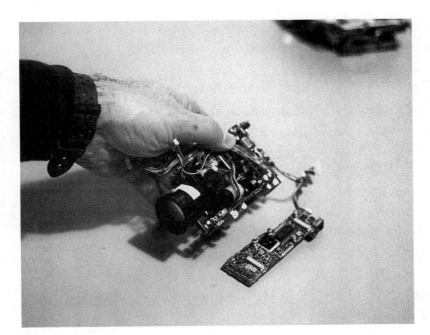

Figure 5.12. Removing the video board.

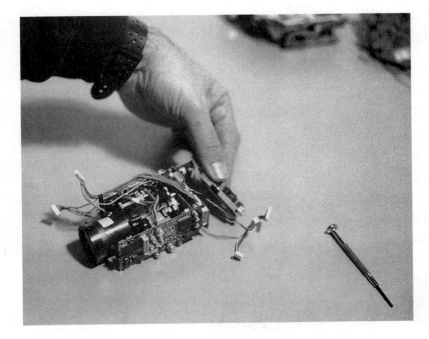

Figure 5.13. Removing the DC-DC converter.

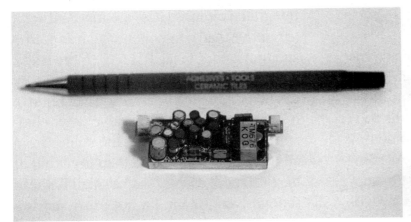

Figure 5.14. The DC-DC converter board compared to a standard size pen.

the operation unit to turn the electronics on and off. Reconnecting the viewfinder also helps.

As you can see, disassembling a camcorder is a tedious job, and we didn't even cover the mechanical parts (we'll do this in a later chapter).

Re-assembly of the camcorder is, obviously, the opposite of disassembly. Re-assembly requires that you remember all the steps involved in disassembly, which is sometimes difficult to do. Again, if you don't have a service manual, use as much backup material as you need. Use labels, drawings and diagrams or even Polaroid photos to assist in the re-assembly process.

It is not uncommon, during disassembly and re-assembly, to break off a wire or otherwise damage the camcorder. When you put the camcorder back into operation, you may find a problem different from the original one. For example, if you break off or forget to connect the wire going to the microphone, you will find that your recordings are missing sound when you perform the final checkout. Don't despair if this is the case. You are probably not looking at a major repair, but more likely just soldering a wire back into place.

5.2 Handling the Camcorder

When you first place a camcorder on the bench, it is usually upright and may have a battery attached to it. When you begin the repair, the first thing you should do is remove the battery. You'll need to do this anyway to remove the rear cover. As mentioned earlier in the book, it's best to supply power to the camcorder with a regu-

lated power supply. You don't want to be confused by a weak battery.

Once you remove the cassette cover to look at the mechanism, don't be afraid to turn the camcorder on its side or upside down. Don't drop the camcorder and don't force anything. In other words, don't force any of the mechanical parts to move back and forth. Instead, apply voltage to the loading motor if you want to watch the mechanism in action.

5.3 Replacing Components

Replacing camcorder components is not an easy job. The PC boards are small, the components are jammed together, and many are surface mount devices. Full-size camcorders are not as bad in this regard as the smaller models. In any case, desoldering components demands skill. The job is more straightforward, though, if you are desoldering standard through-hole components.

Removing solder with a solder sucker is relatively easy. You remove the solder from the leads of the component, and it comes out very easily. You should never exert force to remove a component; this can easily damage it.

Integrated circuits (ICs) are more difficult to remove than components such as diodes and transistors, since ICs have more leads. A microprocessor, for example, typically has 60 or more leads. But, you can remove ICs the same way you remove other components. Simply remove the solder from all the pins of the IC and then pry it out of the PC board, usually with a small flathead screwdriver. Again, do not exert any un-

reasonable force. If an IC is completely desoldered, it will come out without too much effort on your part.

Sometimes, components will have a mechanical attachment to the PC board in addition to the solder. This occurs during the manufacturing process when a component's leads are bent after insertion into the holes on the PC board. You may have to use a small screwdriver or a long-nose pliers to undo the mechanical bond while you are melting the solder.

Desoldering electronic components demands good coordination. You will be holding a soldering iron in one hand and a solder sucker in the other. Solder suckers are usually spring loaded, which means you have to press a spring to get them ready to suck the solder. Then, you have to release the spring at the proper time—just as the solder is melting. To do the job right, it helps immensely to have the printed circuit board in a convenient position for desoldering.

You need to bring your soldering skills up to a certain level before you can become proficient doing repair work. If you are having difficulty with the desoldering and resoldering process, you should practice on older electronic equipment, for which you no longer have any use.

Surface mount devices are a different breed of component. First, you have to use a solder wick to release the solder. Then, you have to pry the component from the PC board, because it is glued to the board at the factory. The glue is used to hold components before they are soldered in place.

To insert a new component, you need to place a little bit of glue on its bottom. Once you glue the component in place, you solder it using a very small soldering iron and a small amount of solder.

Figure 5.15a shows how a typical surface mount transistor is held to a PC board. To remove the part, place the soldering iron on one lead of the part as shown in **Figure 5.15b**. When the solder melts, lift the part up on one side with a tweezer as shown in **Figure 5.15c**. Then, heat the other two leads simultaneously and pull the chip up as shown in **Figure 5.15d**.

Surface mount integrated circuits are even more difficult to remove and replace. These tiny ICs have pins on all four sides. In order to release the solder on all the rows of pins simultaneously, you need a special soldering iron that is shaped like the IC. The iron is placed on top of the IC and it desolders all of pins at the same time with a vacuum pump action. These tools are quite expensive and mostly used in factories and service centers that do rework on printed circuit boards.

Another way to remove surface mount ICs is by removing the solder with a solder wick very carefully and then prying them up with a small flathead screwdriver. You have to do this very carefully so as not to break the copper traces. The traces are very thin and very easy to break.

Replacing surface mount devices is a time consuming and difficult operation. You should not even attempt to do it unless you have some experience. How do you gain experience? Practice, of course. If you have

some old electronics equipment (not too old) such as a personal stereo or a TV (the tuner section), you can practice soldering and desolding all the surface mount parts.

5.4 Repairing Cracked Solder Joints and PC Boards

Cracked or broken solder joints can completely disable a camcorder. The cracks may occur through abuse, in which case you have to track them down. Or, you may inadvertently break a joint or pad during the course of a repair.

Simple cracks and cold solder joints can be repaired by melting the old solder with an iron and adding a bit of new solder to the joint (**Figure 5.16**). More involved cracks, possibly of a pad or trace, are best fixed by soldering a jumper wire to the PC board. The jumper wire takes the place of the broken or cracked pad or trace.

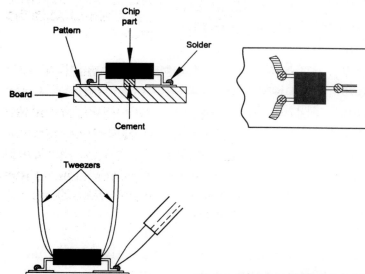

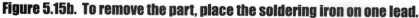

Figure 5.15a. A typical surface mount transistor on a PC board.

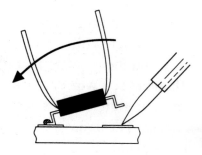

Figure 5.15b. To remove the part, place the soldering iron on one lead.

Figure 5.15c. When the solder melts, lift the part up on one side with a tweezer.

Figure 5.15d. Heat the other two leads simultaneously and pull the chip up.

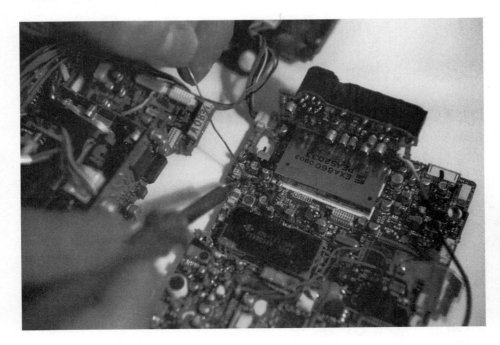

Figure 5.16. Simple cracks and cold solder joints can be repaired by melting the old solder with an iron and adding a bit of new solder to the joint.

If a PC board cracks for some reason, possibly the camcorder fell on the floor, it can usually be repaired. The proper way to do this is to first glue the pieces of the board back together. When the glue dries and the board is back in one piece, you have to scrape the conformal coating off of the broken traces on PC board. You can do this with a sharp tool, such as an X-Acto™ knife. Then, you have to solder a jumper wire to connect the broken pieces of the trace. If traces are very close together, you have to be very careful that jumper wires don't touch each other and that solder doesn't create a bridge between them.

Chapter 6
General Camcorder Maintenance Procedures

A camcorder, just like any other mechanical assembly, requires maintenance from time to time. Cleaning and lubrication should be performed at regular intervals, though many people use their camcorders until they stop working. A camcorder may operate for several years before it experiences a problem. When a customer brings an older camcorder, usually the full-size models, into the shop for repair, you can be certain that it also needs some general maintenance. If you fix the problem and don't attend to the maintenance, you may see the camcorder back in the shop in a very short time. Worse yet, you may incur the wrath of the customer. If you are servicing your own or a friend's camcorder, you don't want to have to fix it again right away. Not only is this a nuisance, but it also reflects on your ability (or inability) to do a thorough job.

6.1 Cleaning and Lubricating the Camcorder Mechanism

Whenever you play a tape, a little bit of dust is released. This is especially true of new tapes. The dust gets into the bearings of the capstan motor and on the surface of the rubber pinch roller. Eventually these pieces become dirty or worn out. When a camcorder comes in for servicing, you have to pay attention to whether a part requires replacement or just needs cleaning.

Figure 6.1 shows the tape transport mechanism of a typical VHS (full-size) camcorder. Generally speaking, the cap-

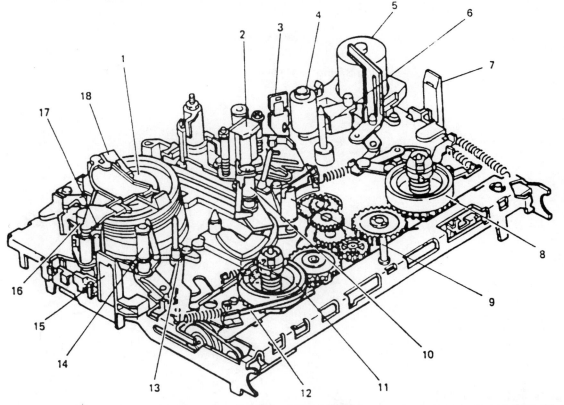

Figure 6.1. The tape transport mechanism of a typical VHS (full-size) camcorder: 1) upper cylinder (video head), 2) audio/control (A/C) head, 3) dew sensor, 4) pinch roller, 5) capstan motor, 6) capstan shaft, 7) take-up end sensor, 8) take-up reel disk, 9) end LED, 10) take-up guide roller, 11) supply reel disk, 12) tension band, 13) tension arm, 14) supply guide roller, 15) supply end sensor, 16) impedance roller, 17) full erase head, 18) cylinder brush. *Reproduced with the permission of Hitachi Home Electronics.*

stan shaft should be cleaned until it shines like a mirror. You should not see any tape residue. The pinch roller should be cleaned as well as all the tape post guides. Again, these should be shiny; you should not see any trace of dust from the tape. Some camcorders have small posts that control the tape coming from the pinch roller and the capstan. These have to be cleaned, too.

After the cleaning is done, you should place a couple of drops of oil on the bearing of the capstan and the pinch roller and a drop each on the tape spindles. Don't stick an oil can into the camcorder to do this lubrication. Instead, do what the old watchmakers used to do. They lubricated watches by dipping a horse hair (wedged into a match stick) into oil and then letting

the oil run down the hair into the mechanism. You don't have to use a horse hair. You can use a tiny screwdriver instead. Just dip the screwdriver into oil and let it run down the shaft to the spot you want to lubricate.

Appendix E is a case study of a Sony Handycam Pro Model CCC-V9 camcorder. This camcorder's picture was jumpy. The owner was so annoyed, he was ready to throw the camcorder away. The problem was caused by a "frozen" bracket similar to the soft arm assembly shown in **Figure 6.2**. When the spring pulled the arm, it moved in slow motion because the shaft hadn't been lubricated since the camera was purchased! To fix the problem, we dipped the shaft of a small screwdriver into

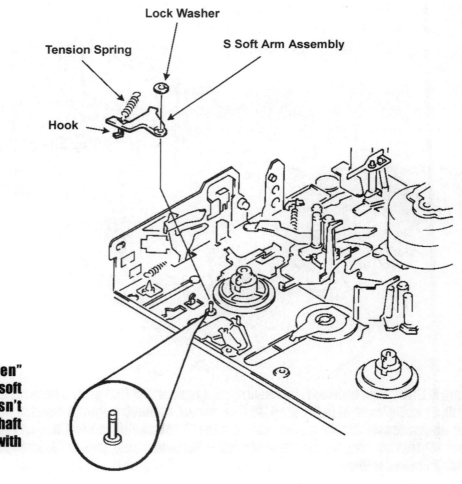

Figure 6.2. A "frozen" bracket in which the soft arm assembly doesn't move freely on the shaft can cause a problem with the video playback.

WD-40 oil and let one drop run down onto the arm's shaft. We repeated the process every five minutes until the arm began to move freely on the shaft. This simple lubrication job returned the camcorder to top condition. The picture was perfect again. Sometimes oil or grease can become as sticky glue over time. This makes the movement of the brackets and spindles very sluggish and adds additional tension to the mechanism.

Whenever you press play or record, the tape guides in a camcorder slide up a track and wrap the tape around the video head. This is a prime area for lubrication, not with oil, but with grease. Follow the old adage, "Oil anything that turns, grease anything that slides." The easiest way to do this is with a grease injector as shown in **Figure 6.3**. You should grease the right and left sides of both tracks on both sides of the chassis, if possible.

Cotton or foam swabs can be used for general cleaning of a camcorder mechanism, but never to clean a video head. For ex-ample, a cotton swab dipped into alcohol is perfect for cleaning belts on VHS camcorders.

6.2 Cleaning the Video and Audio Heads

The video drum assembly in a camcorder contains the video heads and sometimes the audio heads. The heads are located in the uppermost part of this assembly. Most everyone is familiar with the problems caused by dirty video heads. Noise lines begin to appear in the picture and eventually the picture becomes unviewable (**Figure 6.4**). Cleaning tapes help camcorder owners deal with this problem themselves. When a camcorder comes in for servicing, you can do a much better job of cleaning the heads. What's needed are a chamois stick and head cleaning fluid (usually alcohol based). These are readily available at electronics parts stores and through catalogs.

To clean the head, you spray or dip the chamois stick in the cleaning fluid and press it up against the upper drum assem-

Figure 6.3. Greasing the tracks of the mechanism with a grease injector.

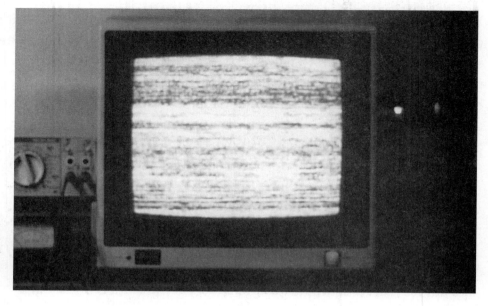

Figure 6.4. Noise lines from dirty or worn video heads can make the picture unviewable.

bly as shown in **Figure 6.5**. Then, you turn the video drum around several times by hand. Don't ever move the stick up and down. Just keep it straight on the head in a vertical position with one hand and turn the head with the other hand. Make sure your hands are clean when you perform this operation, and don't place your fingers on the surface of the drum.

After cleaning, allow a short period of time for the assembly to dry. When you play a tape, you should see a marked difference

in the quality of the picture. If not, the video heads may be worn out and need to be replaced.

At the same time you are cleaning the heads, you also are cleaning the grooves around the upper part of the drum (**Figure 6.6**). These grooves provide small pockets of air around the video drum so the tape doesn't adhere to the highly polished aluminum. In effect, the tape rides on a cushion of air assuring that the tape doesn't get stuck to the drum. If there were no grooves,

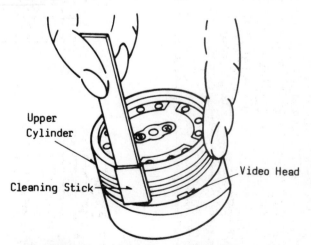

Upper Cylinder

Video Head

Cleaning Stick

Figure 6.5. Cleaning the video heads with a chamois stick dipped in cleaning fluid.
Reproduced with the permission of Matsushita Electric Industrial CompanyLtd.

Figure 6.6. At the same time you are cleaning the heads, you also are cleaning the grooves around the upper part of the drum.

the camcorder would not work. The tape would stick as if glued to the highly polished surface. As these grooves become dirty or wear out, increased pressure is put on the tape. It becomes difficult, if not impossible, to adjust the tape tension. These grooves have to be cleaned thoroughly and very carefully. The best way to clean them is with the chamois swabs as you are cleaning the video heads.

One other part of the drum assembly needs to be cleaned. It is the diagonal groove that the tape rests on when in the play or record position (**Figure 6.7**). This groove can be cleaned in the same manner as the grooves in the upper part of the assembly. Place the chamois or cotton swab on the groove and turn the drum. If you use a cotton swab, make sure you don't make any contact with the tiny video head.

In VHS camcorders, there are two other head assemblies that need periodic cleaning. One is the audio/control head assembly and the other is the erase head assembly. These can be cleaned with a cotton or foam swab dipped in alcohol or a head cleaning fluid. These heads are stationary, so you have to move the swab up and down and from side to side to clean off oxide deposits and other contaminants.

The erase head assembly can be found in the tape path on the left hand side of the video heads as shown in **Figure 6.1**. Naturally, when you are recording a tape, the tape has to be erased before it can be recorded on again. This means that the tape must pass over the erase head before it passes over the video heads. The audio and control heads are usually together in one assembly. These heads are located on the right hand side of the video heads.

Not all camcorders have these separate heads. In VHS-C and 8 mm camcorders, the audio head is often integrated with the video head on the drum assembly. A flying erase head also is integrated onto the drum. For these camcorders, the process of cleaning the video heads as outlined above also cleans the audio and erase heads.

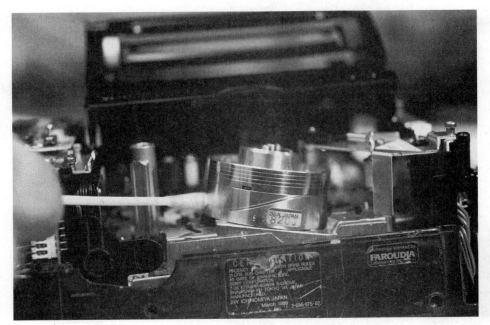

Figure 6.7. Cleaning the diagonal groove on the video drum assembly using a cotton swab dipped in cleaning fluid.

6.3 Checking Belts

All camcorders employ belts and pulleys, some more than others. After many years of operation rubber belts can lose their spring action. In other words, they stay stretched out when you pull on them (**Figure 6.8**). If you pull on a belt and the elasticity seems to be missing, it is time to change the belt. If you remove a belt from a pulley and set it down on a table, it should form a circle or ellipse. If it forms an odd pattern, such as a peanut shape, you can be sure the belt needs to be replaced.

Belts also can pick up grease and dirt after years of operation. This will cause the belt to slip. A simple remedy is to clean the belt with a cotton or foam swab dipped in a degreasing fluid.

Sometimes, if you examine a belt closely as you stretch it, you will see tiny cracks. This is a classic sign that the belt needs to be replaced. There is no remedy for this.

You're more likely to find standard rubber belts in older VHS camcorders. The newer 8 mm and VHS-C camcorders use thin nylon toothed belts like the one shown in **Figure 6.9**.

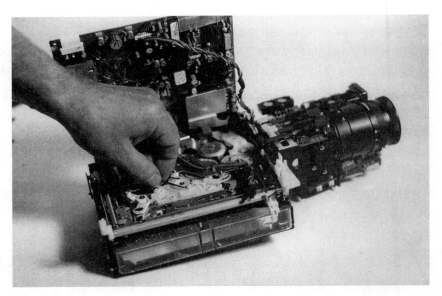

Figure 6.8. Pulling on a belt to test its elasticity.

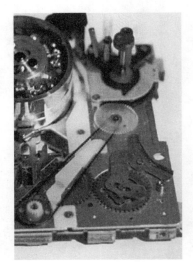

Figure 6.9. 8 mm and VHS-C camcorders use thin nylon toothed belts.

Chapter 7

Determining the Problem

Good troubleshooting procedure begins with a brief description of the problem from the camcorder's owner. A description of symptoms and any special circumstances, such as if the camcorder has been dropped, can point you in the right direction for the repair. After this introduction to the problem, you should examine the external parts of the camcorder to determine its condition and then apply power. Try all of the features to determine what is working and what is not. Then you must try to determine whether the camcorder has a mechanical or an electrical problem. Your powers of observation will greatly help you to determine where the problem lies.

7.1 Checking for Mechanical Problems

In our experience, most camcorder problems are mechanical in nature. Why is this the case? A camcorder is typically powered by a battery of 6 VDC or 12 VDC. This means that there is very little high voltage stress or heat generated inside the camcorder. Since stress and heat are the major causes of failure in electrical equipment, a camcorder is designed to be a very reliable product electrically.

The same cannot be said for a camcorder's mechanical reliability. A camcorder's mechanism is relatively fragile. Forcing tapes into the camcorder or trying to put them in backwards can stress the mechanism. Also, a failure to properly maintain the camcorder can lead to problems with belts, gears, levers, arms and so forth. Additionally, mechanical parts are simply not as reliable as electronic components.

If the camcorder comes on when you power it up, place a tape in the machine. If it seats properly, check the camcorder's two major functions: recording and playback. In the record mode, if you can see a picture in the viewfinder, it is a sign that the electronics are in good working condition. Try to make a recording.

If recording works, switch the camcorder to the playback mode. Then, try to play the tape. If it plays, then you should try all the rest of the functions.

At some point in the record/play process, you should be able to verify the trouble symptoms described by the owner of the camcorder. If not, you probably have an intermittent problem.

If you are thwarted in your attempts to load and operate the camcorder, you need to remove the cassette door and investigate the problem further. With the door off, it is easier to see if the problem is mechanical in nature. If the tape will not load into the machine, you may have a problem with the cassette loading assembly. This particular part of the machine has a variety of names, depending on the manufacturer. Some common names are cage, cassette housing, loading cage and cage assembly.

A failure to load or eject a tape can be mechanical or electrical in nature. If it is mechanical, a gear may be out of place or a belt may be broken. If the owner tried to force the tape into the machine, metal parts of the loading assembly may be bent or plastic parts may be broken. A good point to start your troubleshooting in full-size VHS camcorders is to observe the condi-

tion of the loading motor and listen to any noises that it makes. Try to determine if the motor is spinning and whether or not a belt or gear is engaged. A broken or slipping belt may be the source of the problem. Again, locating the problem depends on your powers of observation. **Figure 7.1** shows the location of the loading motor in a Hitachi VM-5000A VHS camcorder. This belt was slipping, and thus the camcorder would not play or record and sometimes had trouble ejecting a tape. The slipping belt caused the loading problem,

but a loud whirring noise served as a clue to the problem.

If the loading motor seems to be working okay, you should carefully examine all the mechanical linkages of the cassette housing. This is best done with the housing removed from the camcorder. To remove a cassette housing, remove the screws that secure it to the chassis. Then remove any connectors to the main circuit board. **Figure 7.2** shows a cassette housing removed from a VHS-C camcorder.

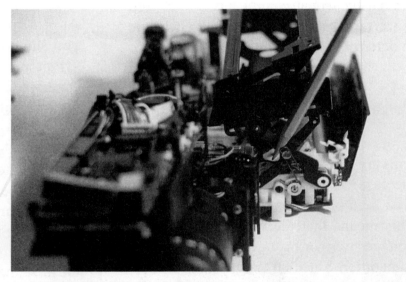

Figure 7.1. The location of the loading motor in a Hitachi VM-5000A VHS camcorder.

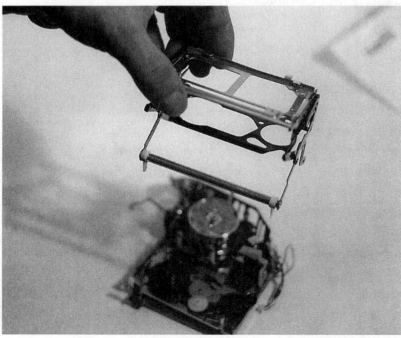

Figure 7.2. A cassette housing removed from a VHS-C camcorder.

Sometimes the housing will not come out easily. You may have to wiggle it around a bit to dislodge it. Pay close attention to the positions of the pieces. Remember, you will have to put the housing back in place eventually. Once you remove the cassette loading assembly from the camcorder, you can examine its operation more closely.

When you press play or record almost every mechanical part in the camcorder springs into action. Gears turn and levers move both on the top and bottom of the camcorder. From the top, you can watch as the tape guides pull the tape out of the cassette, slide up the tracks in the chassis, and wrap the tape around the video head drum. When you observe this operation, make sure the tape is moving and that the tape guides are sliding all the way up to their final position. Any broken links may cause the tape guide to stop prior to seating at the end of its run.

Another part to watch closely is the pinch roller. This piece should swing into place firmly against the capstan shaft. The pinch roller and capstan shaft work together to pull the tape out of the cassette. The capstan shaft is powered by the capstan motor and, thus, should be turning. The rubber pinch roller should provide enough friction to move the tape. **Figure 7.3** shows the tape path of the JVC GR-AX7U VHS-C camcorder.

A test jig is very useful tool for figuring out if the mechanical parts of the camcorder are working properly. It is the same size as a cassette tape, but is made of clear plastic. When you place it in the camcorder, the machine acts as if a real tape had been loaded. You get a birds-eye view of all the parts usually hidden underneath the tape, such as the idler arm assembly. Plus, you can see all the parts move when you press a key such as play. If you

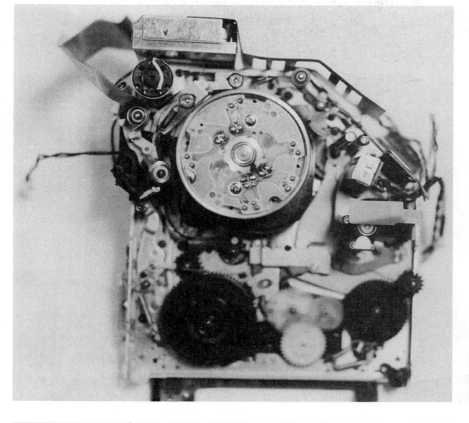

Figure 7.3. The tape path of the JVC GR-AX7U VHS-C camcorder.

don't have a test jig, you can place a piece of opaque tape or a small rubber tube over the end LED as shown in **Figure 7.4**. This affords you the same opportunity to observe the mechanism in action.

For a thorough check of the mechanism, you have to look underneath the chassis. You may think that this is simply a matter of removing the right side cover of the camcorder, but this is not always the case.

Some camcorders are constructed with the main circuit board screwed to the bottom of the mechanism. When you remove the cover on the opposite side of the mechanism, you get a perfect view of the camcorder electronics (**Figure 7.5**).

No matter how the camcorder is constructed, the bottom of the chassis contains many pulleys, gears, springs, levers and belts that make the camcorder go. Finding

Figure 7.4. If you don't have a test jig, you can place a piece of opaque tape or a small rubber tube over the end LED. *Reproduced with the permission of Thompson Consumer Electronics.*

Figure 7.5. When you remove the cover on the opposite side of the mechanism, you get a perfect view of the camcorder electronics.

a mechanical problem often demands patience and the ability to figure out how all the parts work together.

Another clue to mechanical problems are the noises the camcorder makes when it is playing. You may hear the whirring noise of a motor or the grinding sound of a gear. Any strange noise is an indication that one of the mechanical parts is not functioning properly. For example, sometimes you'll hear noise coming from the video drum assembly. Usually, this noise is caused by bad bearings in the drum motor.

If the customer complains about poor video, you might think that the problem is electrical rather than mechanical. This is not always the case. If a tape guide goes out of alignment, the symptom of the problem is tearing or jumpy video. In the next chapter, we will cover this problem in more detail.

7.2 Checking for Electrical Problems

A camcorder is a battery powered device. As long as the battery or AC adapter is providing sufficient power, the camcorder should never appear to be "dead" as other AC powered electronics sometimes do. If you are not sure of the condition of the battery or AC adapter, you should use a bench-type regulated supply for power. It may seem hard to believe, but we have gotten camcorders in for repair just because the battery is dead. We are as surprised as anyone when we connect the bench supply to the camcorder and it works perfectly. Keep in mind, too, that many camcorders shut down when the voltage dips below a certain level. If the battery is not holding a charge, the camcorder may play for 10 seconds and then shut off. A new battery will solve this problem.

When you apply power to a camcorder and turn it on, you should immediately check the viewfinder. You should see a raster and may also see information provided by the camcorder. With a tape in the machine and the camcorder set to the camera mode, you should see a picture on the display (lens cap off, of course). If there is no raster or you fail to see a picture while in camera mode, then you know you have an electrical problem. The camcorder may have a problem with the DC-DC converter, video board, CCD sensor or the CRT (or LCD panel).

In a case like this, the first thing to check is the DC-DC converter. The battery or AC adapter supplies voltage at one level, either 6 VDC or 12 VDC, but the camcorder needs other voltages to operate properly. It is the job of the DC-DC converter to provide these voltages. If the camcorder is missing one or more voltages, certain sections will not work. You can check the outputs of the DC-DC converter with a DMM set to measure DC volts.

Another indication of an electrical problem is erratic operation of the camcorder. Sometimes, when you press play, the camcorder fast forwards or goes into reverse. This "mixed up" behavior often points to a defective or dirty mode switch.

Sometimes the camcorder will play, but the counter will not count. Then, after several seconds, the camcorder shuts off. This can be caused by a defective sensor under the right or left reel disk. On some camcorders,

if you lift up the reel disk and turn it over, you will see a pie-shaped pattern (**Figure 7.6**). This pattern works in conjunction with a special sensor to send pulses to the counter circuits in the camcorder.

If the customer complains about poor video, the problem may be caused by the video heads or tracking circuits. Connecting the camcorder to a monitor helps you determine the source of the problem. If there are lines all over the picture, the video heads may need to be cleaned or replaced altogether. If there are lines in one area of the picture, there may be a problem with the tracking circuits.

Sometimes, you may notice that the video head does not spin at a constant rate, but instead slows down, increases, and slows down again. This is an indication of problems in the servo circuits, since these circuits control the speed of the motor.

Electrical problems often occur when the printed circuit board itself has problems. Typical PCB problems are cracked solder joints and broken traces. These problems can sometimes be found by close inspec-tion of the PC board with a magnifying lamp or glass. Other times you can only find them by applying pressure to different areas of the circuit board.

7.3 Checking for Problems Caused by Abuse

If a camcorder has been dropped, stepped on or abused in any other way, it usually suffers external or internal (or both) physical damage. On the outside, the cassette door may be bent or the area around the lens broken. On the inside, you may find a cracked printed circuit board or broken connectors.

Sometimes the results of abuse are obvious, sometimes not. It is very important, though, to know what has happened to the camcorder. The case study of JVC GR-AX7U in Appendix A is good example. The owner of this camcorder told us it had been dropped. There were no obvious signs that it had been dropped, but the information from the owner gave us a head start in locating the problem.

Figure 7.6. On some camcorders, if you lift up the reel disk and turn it over, you will see a pie-shaped pattern.

Chapter 8

Troubleshooting Mechanical Problems

Camcorders are complex mechanical machines employing gears, pulleys, springs, levers, belts, brackets, wheels and other parts, all driven by small motors. Repairing the mechanical parts of a camcorder certainly demands mechanical aptitude. You have to know how to take assemblies apart and how to put them back together.

Since the majority of problems in camcorders are mechanical in nature, it is imperative that you understand very well how all the parts are supposed to work together. This chapter tells you about some of the things that can go wrong mechanically in a camcorder.

8.1 Checking Gears, Belts, and Springs

A visual inspection of the camcorder will show if gears are worn out, cracked or have broken teeth. A broken gear is obvious (**Figure 8.1**) once you find it. As detailed in Appendix F: Case Study 6, the plastic gear of the mode switch of an RCA Model PRO843 8 mm camcorder had two broken teeth. This was easy to spot once we took a look at the gears on the underside of the mechanism. These two broken teeth upset the alignment of the mechanism and caused the camcorder to act like it was in the pause mode when you pressed play.

Rubber belts are used in VHS camcorders, while very thin nylon toothed belts are used in VHS-C and 8 mm camcorders. To check a rubber belt, you have to stretch it a little to see if the belt is cracked or has lost its elasticity. If it is cracked or loose it must be replaced. Another way to check the belt is to hold the wheel that it is turning. If you feel a good resistance, the belt is good. If there is very little resistance, the belt needs to be changed.

Toothed belts are different. They are not elastic, but tend to enlarge over time. Camcorders that employ toothed belts usually have a provision for adjusting the tension on the belt. Typically, this is a small wheel with a bracket mounted with a single screw. When you loosen the screw you can move the wheel and increase the tension.

Figure 8.1. This broken gear has two missing teeth.

When replacing belts, there is a device you can use to check the length of the old belt against the length of the replacement belt. You place the old belt over two of the shafts to take a measurement. The new belt should measure slightly smaller than the old belt (**Figure 8.2**).

Springs cause problems when they detach or suffer metal fatigue. If a spring is detached, you should check why this happened. Maybe the end of the spring is broken or the spring has loosened and doesn't hold in the holes anymore. If the spring is broken it needs to be replaced with a new one.

As described in Appendix D: Case Study 4, a Quasar QuarterBack VM500 camcorder supplies back tension with a spring. This spring is connected to a tension band that wraps around the supply reel. The spring has three levels of adjustment. It may be placed on one of three square plastic pegs, which are at different heights. By moving the spring from peg to peg, you adjust the tension. As the machine gets older, the spring may have to be moved up or down a peg. If the spring is on the top or bottom peg and needs further

adjustment, it may be necessary to cut the spring or do the opposite, stretch the spring, to get more or less tension.

This is a common problem with springs. If you can't obtain the correct tension by moving the spring to a different peg, you have to do something else. To shorten springs, you can cut off the ends with a wire cutter. To lengthen springs, you can stretch one or more coils with a small screwdriver. Of course, another way to address the problem is by purchasing a new spring.

8.2 Checking the Cassette Housing Assembly

The typical cassette housing assembly in camcorders folds down when you insert a tape into the machine and pops up when you press the eject button. Motors do not control the action of the assembly; rather, springs control it. That is, you press the mechanism down until it locks in place. When you press the eject button, the lock is released and the force of the springs opens the assembly. This mechanism is generally reliable and should not be a source of problems unless a tape has been

Figure 8.2. A device to check the length of an old belt against the length of the replacement belt.

forced into the camcorder or the camcorder has beendropped. You very rarely see camcorders with tapes stuck inside.

If you notice that the cassette housing assembly is damaged and not doing its job, you have to decide whether to try to repair it or to purchase a new one. If a leg of an assembly is bent, it may only need to be straightened out to start working properly again. **Figure 8.3** shows how the cassette housing assembly of an RCA PRO843 8 mm camcorder is removed.

8.3 Checking the Tape Path

You can check the tape path very easily by loading a tape and pressing the play button. **Figure 8.4** shows the tape path of a typical 8 mm camcorder. You need to pay close attention to certain points. First is the pinch roller assembly, the most troublesome spot in the tape path. You have to check that the tape goes in straight and comes out straight.

The second point is the audio head, if there is one (this camcorder does not have a separate audio head). The tape must pass over the audio head without touching the

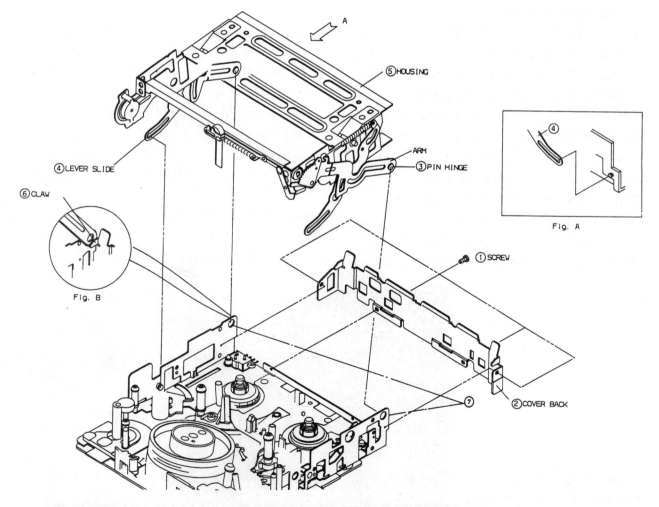

Figure 8.3. Removing the cassette housing assembly of an RCA PRO843 8 mm camcorder. *Reproduced with the permission of Thompson Consumer Electronics.*

shield of the head. The tape has to be smooth, not bent or curled. This way, the audio head reads the signal on the tape properly. On some camcorders, one or more small tape guides are mounted between the pinch roller and the cassette. These guides sometimes become bent, usually by hurriedly pushing a cassette into the camcorder. If the cassette is not properly seated, it may push one of the tape guides out of alignment. A bent guide will damage the tape. The guide changes the tape's height and perpendicularity to the chassis. These guides can be straightened or replaced with new ones.

The third point is the outgoing tape guide (**Figure 8.4**) next to the video head. Over time, the tape guide accumulates oxides, and no longer accommodates the width of the tape. This causes erratic speed control. This guide has to be cleaned very carefully and very gently with a chamois swab, the same type used to clean the video head.

The fourth point is the incoming tape guide (**Figure 8.4**), which is the same type as the outgoing.

The fifth point is the erase head, if there is one (this camcorder does not have a separate erase head). This head has its own guide. On some camcorders, the erase head is mounted on the chassis, on others there is a so-called flying erase head, which is mounted on a spring-loaded shaft. This head is not stationary. To the left of the head there is a tape guide that adjusts the height of the tape relative to the erase head. If there is a problem with the tape curling, you can align this manually.

The tape tension guide (**Figure 8.4**) is the sixth and final point of the tape path and the most important. Tape tension is provided by a small spring. This tension guide is attached to the tension band or string (**Figure 8.5**). This band acts like a brake, putting tension on the tape through the

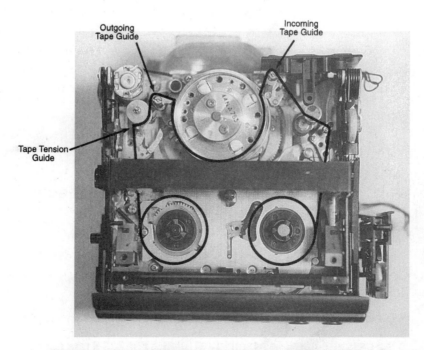

Outgoing Tape Guide

Incoming Tape Guide

Tape Tension Guide

Figure 8.4. The tape path of a typical 8 mm camcorder.

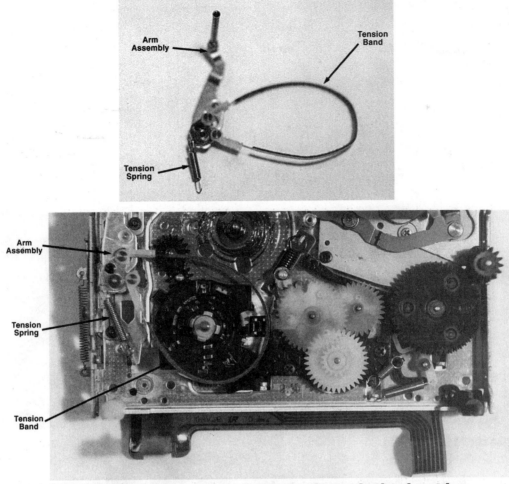

Figure 8.5. The tension guide is attached to the tension band or string.

spring so the tape has contact with the video head. Sometimes the felt on the band wears out, decreasing the tension and distorting the picture. This distortion may result in a picture rolling and covered with noise. If this happens, the tension band should be replaced with a new one.

8.4 Checking Idler Assemblies

The idler assembly transfers power from a vertically grooved plastic wheel (turned by the capstan motor) to the reel disk. The idler assembly is a key component in the fast forward and rewind operations.

On most camcorders, the idler assembly employs a toothed gear. If any teeth of the

gear break, you will have problems with fast forward and rewind. The solution is to replace the idler assembly. The idler assembly removal procedure for the RCA PRO843 is shown in **Figure 8.6**.

8.5 Checking Mode Switches

The mode switch is usually a multi-position rotary switch with a gear attached (**Figure 8.7**). This switch signals the microprocessor regarding the status of the mechanical assembly at every moment. If you want to eject a tape while it is fast forwarding, the mode switch signals the microprocessor that the tape is fast forwarding. The microprocessor stops the tape first and then ejects it.

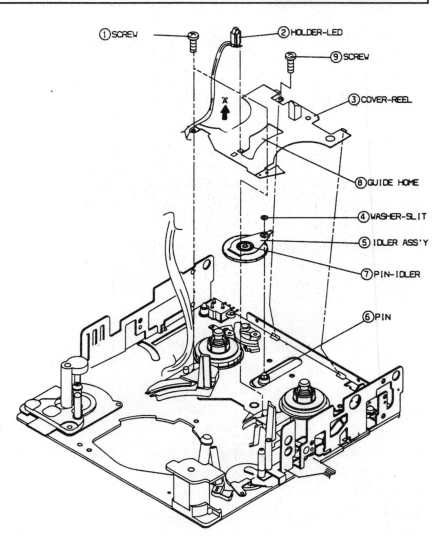

Figure 8.6. The idler assembly removal procedure for the RCA PRO843. *Reproduced with the permission of Thompson Consumer Electronics.*

Figure 8.7. The mode switch is usually a multi-position rotary switch with a gear attached.

For the mode switch to work properly, it must be correctly aligned with the whole mechanical assembly. The position of the mode switch is usually signified by a dot on the wheel and a mark on the body of the switch. The proper alignment of each camcorder depends on the manufacturer. Sometimes the dot and mark come together when the cassette is out of the machine. But this is not the case in all machines. If you are not sure how the mode switch should be aligned, you must refer to the service manual.

Appendix F: Case Study 6, shows how to align the gears of an RCA Model PRO843 8 mm camcorder. This alignment had to be done after replacing the mode switch, which had a gear with two broken teeth.

Many times the problem with the mode switch is dirty contacts. This can create all sorts of problems. The symptom is an erratically functioning camcorder. You press fast forward and the tape doesn't move, or the power shuts off. Or else, while the machine is playing, it starts fast forwarding by itself.

You can clean the mode switch by spraying it with WD-40 lubricant. Spray the switch, press PLAY to turn it, spray it again, and press PLAY again. Spray the mode switch from the side. If you remove the mode switch from the camcorder, you can turn it manually. Usually the mode switch is not easily accessible and requires extensive disassembly to service it.

8.6 Mechanical Adjustments

Mechanical adjustments can be done by hand, but it takes some experience. If you are not successful, you will have to purchase specialized tools such as a tension meter or torque cassette. However, these are expensive.

Before we begin, you should know that mechanical adjustments are not always needed. Suppose a problem, such as tape curling, occurs due to a defective pinch roller. If this is the case, all you need to do is replace the pinch roller. No further adjustments are needed. Even if you replace the video head, you rarely need to do any mechanical adjustments.

A mechanical adjustment is usually needed after replacing a broken tension band (**Figure 8.8**). Then, you have to do a tape tension adjustment, which involves adjusting the tension on a spring. This adjustment can be done without a meter or torque cassette, but you have to have a feel for it. The tape tension cannot be too loose or you will lose the top half of the picture. If it is too tight, the video head will wear out prematurely and may produce a jittery sound.

One of the ways to make the adjustment is to loosen the spring until you lose the top half of the picture or the picture becomes shaky. Then, incrementally increase the tension on the spring, while observing the picture quality. Stop at the point where you see a good picture. Since this adjustment varies from camcorder to camcorder, it is up to you to figure out how to adjust the spring. If you can't figure it out, you have to purchase the service manual.

The brakes (**Figure 8.9**) sometimes need adjustment, if the machine allows it. If not, you must change the brake pads. The ba-

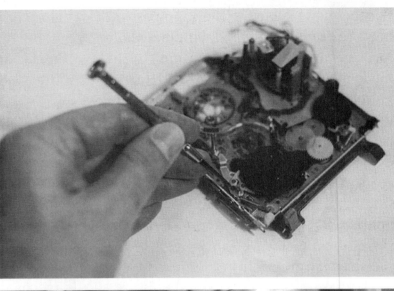

Figure 8.8. A mechanical adjustment is usually needed after replacing a broken tension band.

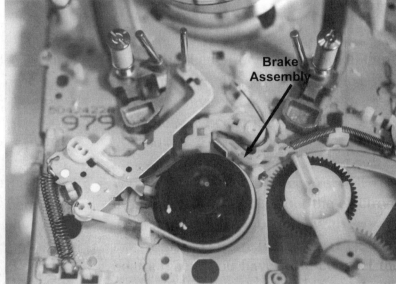

Brake Assembly

Figure 8.9. The brakes sometimes need adjustment, if the machine allows it. If not, you must change the brake pads.

sic rule for adjusting the brakes is this: With the camcorder in STOP mode and the tape out of the machine, turn the right reel disk to the right until the resistance is equal to turning the left reel disk to the left.

8.7 Aligning the Tape Guides

In a normal working camcorder, after the tape is loaded into the machine and the PLAY button is pressed, the right and left tape guides move forward to wrap the video tape around the video head. In this process, the height of each tape guide is critical to the quality of the playback video. Normally, the manufacturer presets the height of these tape guides, using a test tape. To make sure these guides will not change position over the course of time, each one has a lock screw.

The lock screw, which can be adjusted with a flat head screwdriver or Allen wrench (depending on the screw), is located at the bottom of the guide (**Figure 8.10**). Unfortunately, one or both tape guides can go out of alignment. When this happens, the tape does not lay perfectly flat on the guide

as shown in **Figure 8.11**, which causes tearing or some other distortion of the picture.

Aligning the tape guides is not very difficult (**Figure 8.12**). To do this you need an alignment tool (a small screwdriver will do in a pinch), a test tape and an oscilloscope. You can purchase a test tape from the manufacturer, but these are fairly expensive. To avoid this expense, you can make a test tape yourself. Naturally, you will need a different test tape for each different camcorder format. We use a new 4-head VCR to produce test tapes for VHS camcorders, a new 8 mm VCR for 8 mm camcorders, and a new VHS-C camcorder for VHS-C camcorders. We make a 5-minute recording of color bars (or you can use a 10-step signal), which we obtain from our Sencore Video Analyzer Model VA62A. It is fairly easy to make a test tape if you have a VCR or camcorder in good condition. If you don't have a source for a test signal, you'll have to settle for a standard cable TV recording.

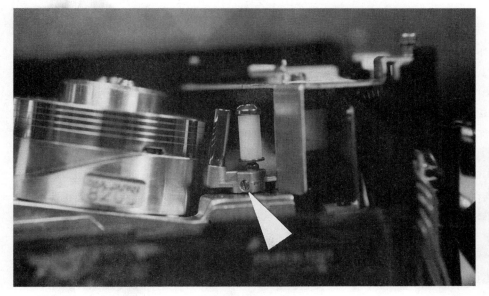

Figure 8.10. The lock screw of a tape guide, which can be adjusted with a flat head screwdriver or Allen wrench (depending on the screw), is located at the bottom of the guide.

Figure 8.11. If one or both tape guides go out of alignment, the tape does not lay perfectly flat on the guide.

Figure 8.12. An alignment tool is one of the tools you need to align a tape guide.

Once you make the test tape, put it in the camcorder that needs to be aligned. If you get an acceptable picture, that is, if the picture is free of noise and is clear, then all you have to do is check the range of the tracking, from left to right. Toward the left side of the tracking control, you should lose the picture. On a properly aligned camcorder, the picture will be snowy all over, not only on the top and bottom or only on the top. The picture must deteriorate gradually, but not in one part, all over the screen. If this happens, then the camcorder has good alignment. If it doesn't happen, the camcorder needs to be aligned. Also, if you have to turn the tracking all the way to the left or the right to obtain an acceptable picture, the camcorder needs to be aligned.

To do the alignment, you need an oscilloscope. Even if the scope is not very sophisticated, it can do the job. You connect the scope to the FM test point in the camcorder and press PLAY. You have to synchronize the scope until the pattern on the screen stops moving, or you can use an external trigger. You can trigger the scope from the 30 Hz head switching signal. Then, the waveform will lock. When you do the alignment, if there is a gap to the right side of the waveform, that means the outgoing tape guide, which is on the right side, has to be aligned. You move it either up or down until you get a straight line on the scope. If the left side of the waveform drops out, then you have to align the left tape guide.

Typical alignment waveforms are shown in **Figure 8.13a**, **Figure 8.13b** and **Figure 8.13c**. The FM test point can be found at the output of the head amplifier, while a good external trigger signal is the head SW pulse. Usually, these points are silkscreened on the PC board. If not, you will have to purchase the service manual.

Sometimes, when you do an alignment, you can't get the line straight no matter what you do. The problem is the tape posts deteriorate over the years, or sometimes they have oxide deposits from the tape, which changes the height of the tape post.

A. Dropping envelope level at the beginning of the track

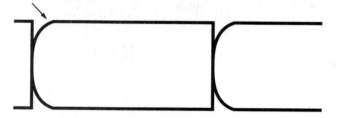

B. Dropping envelope level at the end of the track

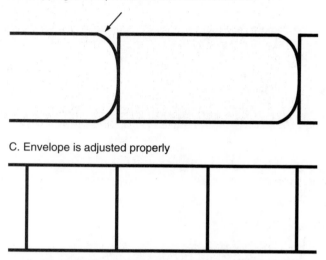

C. Envelope is adjusted properly

Figure 8.13. Typical tape guide alignment waveforms.

If you have this problem, you need to clean the tape post very carefully. Also, you should clean the pinch roller and the audio head, if there is one, very carefully. The position of the audio head has a lot to do with the alignment of the video head. If the alignment is done properly, but you still cannot bring the tracking to the center, then you have to move the audio head slightly to the left or right.

You do not need an oscilloscope to align a tape guide if only one is out of alignment. For example, we aligned the Yashica Samurai Video8 Model KX-77U as described in Appendix C. We simply watched the picture on the video monitor as we adjusted the tape guide with an alignment tool.

8.8 Aligning Gears

If a gear breaks a tooth or jumps a few teeth and goes out of alignment, the camcorder will not work properly. You will notice erratic behavior such as described in Appendix F: Case Study 6. In this case study, a couple of teeth broke on the gear of the mode switch of an RCA Model PRO843 8 mm camcorder.

Aligning gears is a difficult job and often requires a service manual. When you are aligning gears, you will find that certain holes in the gears need to be situated directly over holes in the deck of the mechanism. Also, there are paint marks on gears that are meant to coincide with paint marks on adjoining gears.

You should gain as much familiarity as you can with the names and functions of the various gears in a camcorder. Case Study 6 describes the alignment of the gears in an 8 mm camcorder, so we'll describe the alignment of a VHS-C camcorder here.

Figure 8.14 shows the loading system gears of the JVC GR-AX7U camcorder. To align the gears, the first step is to position the middle pole cam gear so its adjusting hole and the hole of the main deck coincide with each other (**Figure 8.15**).

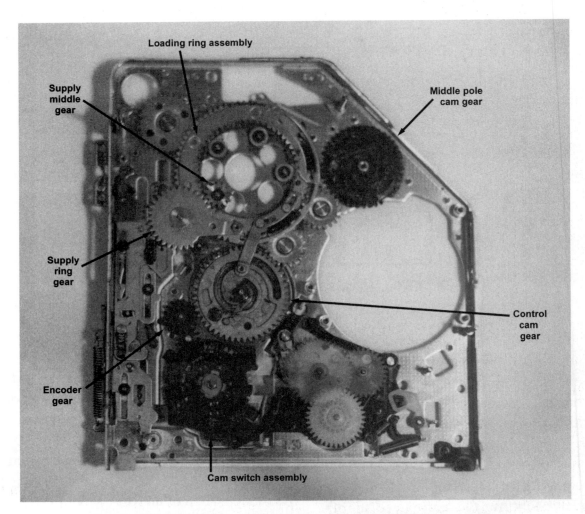

Figure 8.14. The loading system gears of the JVC GR-AX7U camcorder.

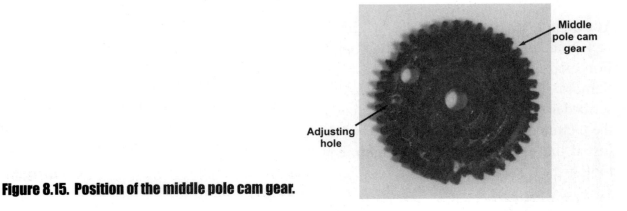

Figure 8.15. Position of the middle pole cam gear.

The second step is to position the control cam gear so its adjusting hole and the hole of the main deck coincide with each other. At the same time, confirm that the holes of the link (located on the back of the main deck) and the hole of the main deck coincide with each other (**Figure 8.16**).

The third step is to engage the encoder gear with the control cam gear so that the mark-ing of the encoder gear is positioned on the imaginary line that passes through the centers of each gear (**Figure 8.17**).

The fourth step is to engage the supply middle gear with the loading ring assembly so that two teeth of the supply middle gear and the internal first two teeth of the loading ring assembly interlock with each other (**Figure 8.18**).

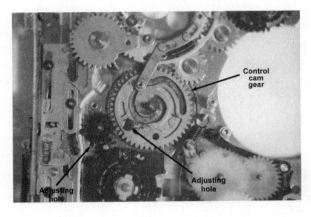

Figure 8.16. Position of the control cam gear.

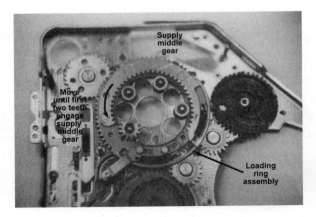

Figure 8.17. Position of the encoder gear with the control cam gear.

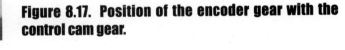

Figure 8.18. Position of the supply middle gear with the loading ring assembly.

The fifth step is to engage the supply ring gear so that its hole coincides with that of the loading ring assembly (**Figure 8.19**).

The final step is to set the cam switch assembly so the notch of its gear teeth coincides with both the rectangle hole (A) and the hole of the main deck (**Figure 8.20**).

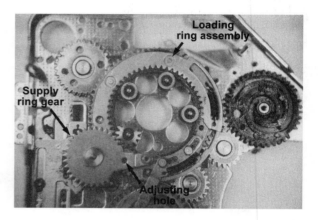

Figure 8.19. Position of the supply ring gear and the loading ring assembly.

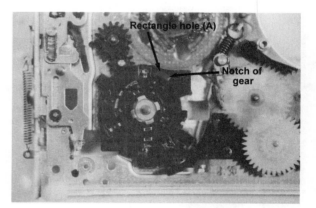

Figure 8.20. Position of the cam switch assembly.

Chapter 9

Troubleshooting Audio Circuits

Audio recording and playback in a camcorder are handled by one or more audio processing ICs. The typical audio input device is the built-in microphone, while audio output is usually available at an audio output jack (standard or proprietary depending on the camcorder) and an earphone jack. Some camcorders, such as the Minolta Master 8-418, rely on the rotating video head for recording audio, while others, such as the Panasonic PV-300, possess a separate stationary audio head for recording and playback.

The Minolta Master 8-418 8 mm camcorder employs a monaural FM recording system (**Figure 9.1**). The audio schematic of the Panasonic Omnivision PV-300 VHS camcorder is shown in **Figure 9.2**.

9.1 Audio Recording

When recording sound, a problem can arise if the bias oscillator for some reason stops working; for example, the transistor goes bad in the oscillator or the coil goes bad. Since part of the bias signal goes to the full erase head to erase the signal from the previous recording, the picture does not get erased. The camcorder may record the new picture, but if you move the tracking adjustment to one side, you will see one recording and when you move it to the other side you will see a different recording. It's like having two recordings on the same stretch of tape. On the recording side, the bias oscillator is an important checkpoint. The bias oscillator is Q4002 in **Figure 9.2**.

Most camcorders have a test point to check the bias level on the erase head and the recording head. It's very important with the recording head to check the bias current. This affects the level of the recording, which is responsible for the audio quality. If the bias level is too high, some of the high frequencies may be erased. If it's too low, distortion will occur. Basically, this is done with the bias level control, which is C4037 in **Figure 9.2**. Some camcorders with separate audio heads do not provide an adjustment for the bias level. If this is the case, you can turn the coil of the oscillator to adjust the bias level.

Keep in mind that the audio head has to be aligned properly in order to record properly. In other words, the height of the audio head is very important as well as the azimuth. This is

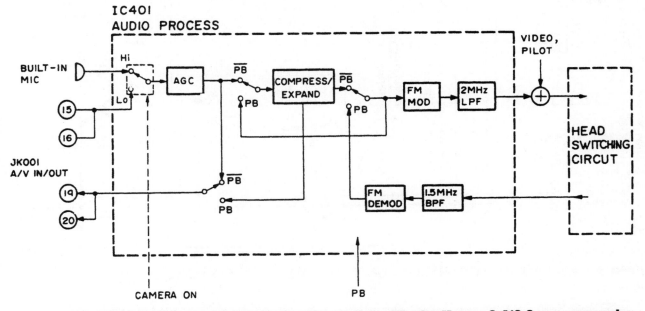

Figure 9.1. Simplified audio signal processing circuit of the Minolta Master 8-418 8 mm camcorder.
Reproduced with the permission of Minolta Corporation.

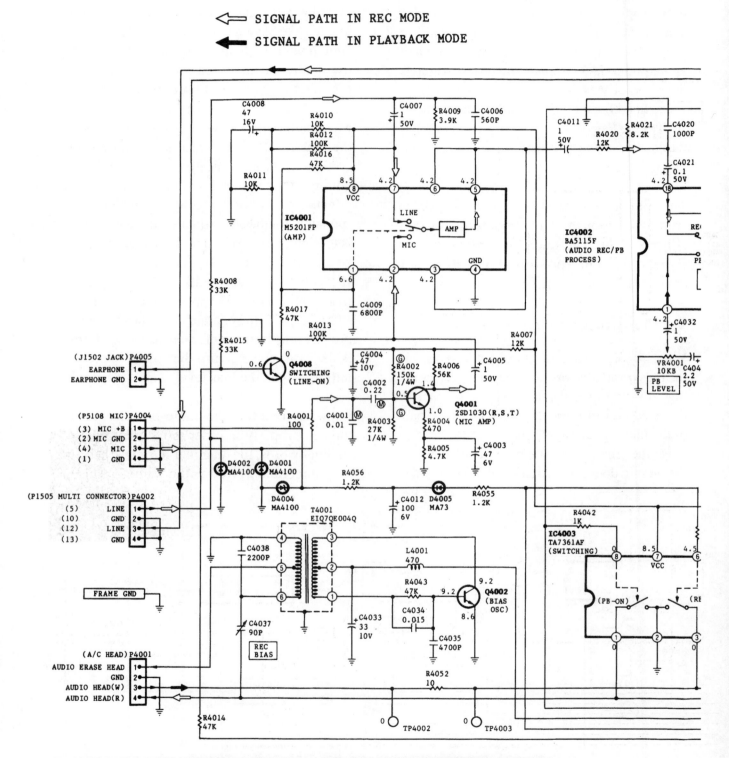

Figure 9.2. The audio schematic of the Panasonic Omnivision PV-300 VHS camcorder. *Reproduced with the permission of Matsushita Electric Industrial Company Ltd.*

so that a tape recorded in one machine can be played successfully in another machine. In general, you should not expect any problems with the recording process unless someone has already fooled with the factory adjustments.

9.2 Audio Playback

Troubleshooting the audio playback circuit in a camcorder like the Panasonic PV-300 is pretty straightforward. You place a tape in the machine and press PLAY. Simply by touching the wires at the back of the audio head, you can find out if the playback amplifier is working. If there is no hum, the problem is not with the audio head, it's with the playback amplifier. If the amplifier is working, you should hear a loud humming noise. If the amplifier does produce sound, the problem could be a defective or dirty head. Also, someone may have changed the level adjustment.

The simplest problem is when the audio head has oxide accumulated on its surface. This causes a low sound level during playback. On a stereo machine, one channel comes through on one level and the other on a different level, depending on how the oxide is distributed over the audio head. The audio head can be cleaned with a cotton or foam swab dipped in alcohol. Carefully rub the swab up and down to remove any oxide deposits.

9.3 Mechanical Adjustments Affecting Audio Circuits

To improve audio quality, you often have to adjust the tension of the tape. Audio recording requires a good mechanical contact between the audio head and the tape. Sometimes, as in Appendix B: Case Study 2, a tape guide needs adjustment. Other adjustments you can perform are for the height and azimuth of the audio head.

To adjust the height of the audio head (**Figure 9.3**), you can use a gauge normally sold by the manufacturer of the camcorder for this purpose. But, it is possible to do the adjustment without the gauge. Use a known good tape recorded on a camcorder or VCR that is in good condition. Insert the tape into the camcorder under repair and press PLAY. The audio head is mounted on a spring loaded shaft. By turning the spring up and down, you can adjust the height of the head. Connect a DMM set to the VOLTS setting to the audio output RCA jack of the camcorder (if it has one). By moving the head up and down you can determine the maximum level of the sound. This is the best position to leave the head.

The azimuth, or tilt, is adjusted the same way (**Figure 9.3** again). The only difference is that when you turn the screw for the azimuth, the

Figure 9.3. Adjustment screws to adjust the height (A, B) and azimuth (C) of the audio/control head. *Reproduced with the permission of Matsushita Electric Industrial Company Ltd.*

head tilts left and right. You have to check it with a tape recorded at a high frequency, in the range of 7 to 10 kHz. When you adjust the azimuth, the maximum voltage level will occur at the highest frequency. This is the right azimuth. You can use a factory tape or one you make yourself.

The signal from the playback head (recording head) goes to a pre-amplifier, which normally has an adjustment for the left and right channels on a stereo machine. Monaural machines have an adjustment for a playback level.

Some camcorders have provision for adjustment, some don't (playback level is set at the factory). Because the audio head is a combination audio head and control head (which reads the speed), there is a small PC board that sits behind the audio head. Sometimes a solder joint cracks and breaks the connection. If this happens, you may hear a humming noise or the camcorder may not record at all. Also, playback may be very low with a humming noise. The connections of the audio head should be checked out anytime you have any audio problems. And, if needed, the connection should be resoldered. On some camcorders, the audio connector may go bad. One solution is to cut the wires from the connector and solder them directly to the head to avoid future problems.

Chapter 10
Checking Sensors and Switches

Sensors and switches provide information to the camcorder's on-board computer about the machine's current status. If a sensor or switch fails, the result is havoc in the camcorder. The computer turns the camcorder off, when it should be on, it fast forwards a tape when it should be rewinding, and so forth. Remember, a camcorder is a very sophisticated electro-mechanical system, dependent on the precise interaction of hundreds of parts. When one small part fails, often the whole system fails.

10.1 Checking Sensors

The on-board computer or microprocessor takes inputs from many sensors. **Figure 10.1** shows some of the sensors of the Panasonic Omnivision PV-300 VHS camcorder. These sensors act as inputs to the microprocessor. Camcorders use many different kinds of sensors. This model uses a photointerrupter, two phototransistors, and a dew sensor just in the cassette mechanism portion of the machine. The phototransistors receive light from an ex-

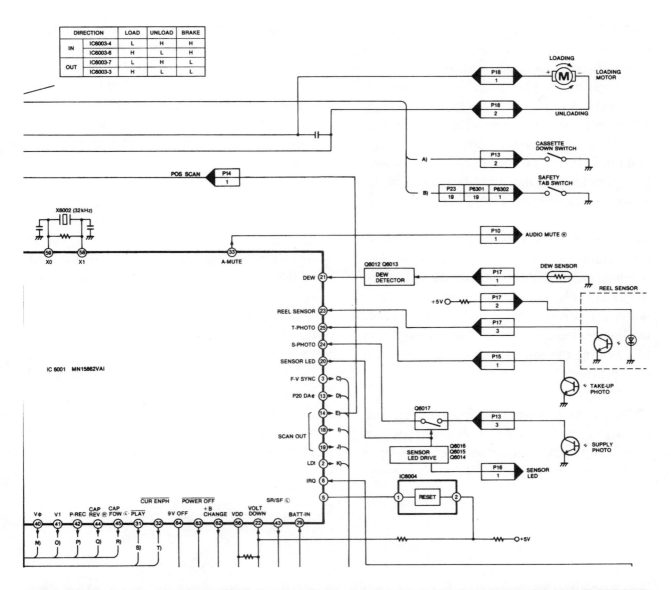

Figure 10.1 A partial schematic showing some of the sensors of the Panasonic Omnivision PV-300 VHS camcorder and their connections to the microprocessor. *Reproduced with the permission of Matsushita Electric Industrial Company Ltd.*

ternal LED, while the photointerrupter is a self-contained unit, both sending and receiving light.

The phototransistors and LED are typically in a triangular shaped arrangement with the LED in the middle of the chassis and the phototransistors on the right and left sides of the mechanism. This trio provide tape-end sensing by sending light from the LED through the transparent leader and trailer of a cassette tape. The phototransistors are often mounted on a small circuit board (**Figure 10.2**).

When the tape reaches the end of its run (either forward or reverse), light from the LED passes through the clear portion of the tape. The appropriate phototransistor senses the light and changes its voltage from low to high. The microprocessor receives the signal and responds according to the current mode of operation. If in the play or fast-forward mode, the operation is switched to rewind. If in the rewind mode, the tape is stopped.

The right side end sensor is also responsible for putting the mechanism in motion. The mechanism does not move until the light from the LED is blocked. This is why you have to defeat this sensor when you are troubleshooting the mechanism. An easy way to do this is by covering the sensor with opaque tape or a rubber tube.

Photointerrupters are often found underneath the take-up and supply reels and are used as a tape counter. A photointerrupter is a 4-pin device with a light emitting diode on one side and a phototransistor on the other. Underneath the take-up or supply reel is a pie-shaped pattern, which alternates between shiny and dark wedges. The light from the LED shines on the pattern and reflects back to the phototransistor. As the reel turns, a pattern of pulses is created, which is sent to the microprocessor. The count is displayed on the camcorder's CRT or LED panel. If this sensor is not working the machine will shut down.

The dew sensor can fool the owner of the camcorder if he or she is not aware of its function. The dew sensor changes its resistance depending on the moisture in the camcorder. Moisture in a camcorder is bad because it causes the tape to stick to the highly polished video head. This is why camcorders have this sensor. If there is a humidity buildup inside the camcorder, the dew sensor signals the microprocessor. Nothing will work until everything dries.

Camcorders are mobile devices. If the owner leaves the camcorder in a car, and the temperature is very hot or cold, moisture can build up inside the unit. Then, when the owner tries to use the camcorder, it won't work. If the camcorder is brought in for repair right away, you may notice that the problem is caused by the dew sensor (camcorders usually will display an error message). A hair dryer can be used to speed up the drying process. To avoid future problems (an irate customer returning the camcorder after another episode with the dew sensor), it is best to inform the owner about the operation of this sensor.

Figure 10.2. Phototransistors are often mounted on small circuit boards. *Reproduced with the permission of Matsushita Electric Industrial Company Ltd.*

You can check the status of any sensor with a DMM set to measure DC voltage. The voltage at a sensor varies from high to low, depending on whether the sensor is on or off. Voltages vary. Some sensors may measure up to 10 volts when on, others may measure only 2 volts. When taking the measurement, the primary concern is whether or not the voltage switches from high to low when you activate or de-activate the sensor. With an LED/phototransistor combination, you can place your finger or an object over the LED or the phototransistor itself. With a self-contained device such as some photointerrupters, you have to use the reflective surface to change the voltage. In other words, you would have to turn a take-up reel by hand to get the sensor to change voltages. For a dew sensor, you can wet your finger, place it right on the sensor, and take the measurement.

10.2 Checking Switches

Of the switches that provide information to the microprocessor, the mode switch is the most complex. Usually, the mode switch is a 4-position switch that connects directly to the microprocessor. Thus, before the microprocessor resets itself, the mode switch has to be in good working condition. If the mode switch is dirty or its gear is broken (as in the case of the RCA Model PRO843 8 mm camcorder of Appendix F), and the proper connections are not made, chances are the camcorder will act erratically or shut off prematurely. For example, if you press the PLAY button, the camcorder may start performing the function and then shut down. You might even think

there is a problem with the microprocessor. But, if the microprocessor fails, nothing will work.

The mode switch is the only switch in the camcorder that needs to be aligned correctly in order to work. In most camcorders, the mode switch looks like a toothed gear attached to a PC board. On the gear, there is a dot that must be aligned with an arrowhead or dot engraved on the plastic base of the switch or on another gear. This alignment also depends on the position of the tape in the machine. Usually, the tape has to be out of the machine when the dots are aligned.

If the mode switch is dirty, it can be cleaned by spraying WD-40 or your favorite contact cleaner (we don't recommend the latter) between the wheel and base of the switch. You should spray a few times until you are sure the contacts are clean.

Another switch usually found in camcorders is a safety tab switch. This switch prevents users from recording on tapes whose safety tab is broken. If this switch gets dirty, it will affect the camcorder's ability to record on blank tapes. This switch can be cleaned by spraying it with WD-40 or by scraping dirt or oxide deposits off the switch with a small screwdriver.

On most camcorders, the position of the cassette housing assembly is monitored with a cassette down switch. If this switch becomes dirty, it can be cleaned in the same way as the safety tab switch.

Troubleshooting Camcorder Displays

There are three kinds of displays you will find in camcorders. Of the three, the most popular by far is the tiny CRT embedded in the electronic viewfinder portion of the camcorder. These are mostly black-and-white displays, but color CRTs can be found on some of the newest camcorders.

A second type of display is the color LCD panel (**Figure 11.1**). This type of display is mounted either on a hinged door of the camcorder or flush at the back of the camcorder. This display is typically used as a secondary viewing screen, but in some cameras is the only screen available.

The third type of display, found on some camcorders, is a monochrome LCD. This type of display, usually embedded in the side of a camcorder, provides text information only and is not used to display video.

Each of these displays, while highly reliable, are susceptible to damage from abuse. Dropping the camera or stepping on it can break any of these displays.

11.1 Troubleshooting CRT Displays

If the CRT in the viewfinder cracks, it is useless and must be replaced. The viewfinder of the JVC GR-AX7U is disassembled as shown in **Figure 11.2**.

Like a TV, a camcorder has several controls to adjust the CRT. These internal controls (**Figure 11.3**) in the JVC GR-AX7U are: focus, brightness, vertical hold, and vertical size. These can be adjusted with a small screwdriver. A word of advice here. If you see the picture jumping as if the vertical hold needs to be adjusted, think about a mechanical problem first. A jumping picture is more likely to be caused by poor tape tension, such as described for the Sony Handycam Pro Model CCC-V9 in Appendix E: Case Study 5.

11.2 Troubleshooting LCD Panels

If an LCD panel cracks you will see a dark blotch on the screen. This is due to the release of liquid crystals. If this happens, whether in

Figure 11.1. Many of the latest camcorder models include an LCD viewscreen.

a color view screen or monochrome display, the panel has to be replaced.

A problem that crops up with color LCDs is the loss of lines, for example, every other line of the picture. This is rare, but if it happens, the panel must be replaced.

Replacing an LCD panel is not a daunting task. Usually, these panels simply need to be pried out of a socket. When putting the new panel into place, you have to be careful not to bend any pins.

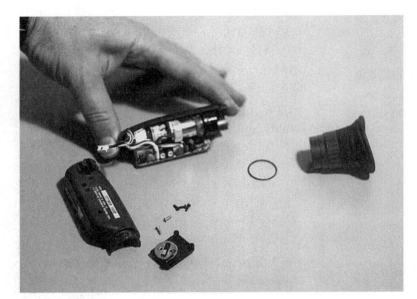

Figure 11.2. The disassembled viewfinder of the JVC GR-AX7U.

| VR04 FOCUS | VR03 BRIGHT | VR01 H.HOLD | VR02 V.SIZE |

Figure 11.3. Internal controls for the viewfinder.

Chapter 12

Troubleshooting Video Heads

Determining if the video head is bad without any special equipment is very difficult. You need equipment, such as a Sencore video analyzer, which is expensive, and then need training on how to use the equipment. This chapter describes how to determine if a video head is bad, without using any special equipment.

12.1 Checking Video Heads

A video head is a very narrow, sharp-edged piece of metal that is very easy to break. If you use a cotton swab to clean the head, for example, chances are you will break the head. A video head is an integral part of the upper video drum assembly (**Figure 12.1**). Most camcorders have either two or four heads, but some have three or five. Even though the drum and the heads are all part of one assembly, most people refer to the entire unit as the video head.

You can better understand the condition of a video head just by looking at it under a magnifying lamp or glass. The video head should look sharp and have a smooth surface. If any part of the surface is chipped, scratched or broken, the head is no good. Then, you have to replace it with a new assembly to make the machine operational.

You can check for a worn video head by applying pressure on the left side of the tape guide. Putting your finger there increases the tension on the tape. If you obtain a picture on the monitor, it means that the head is worn out. When the head is worn out, it doesn't reach the tape to read the signal. If this is the case, the video head has to be replaced.

You will sometimes find a small scratch on the surface of the drum. This scratch cannot be removed or polished. The scratch will scrape oxide from the tape and create a cushion so that eventually the head will not read the tape. If there are any scratches on the video drum, the assembly has to be replaced.

After a camcorder has been used for many years, the video head may wear down but still produce a good picture. But another problem can occur. The surface of the drum has a series of tiny lines or grooves all around it (**Figure 12.2**). These grooves serve a purpose. They prevent the video tape from adhering to the video head drum, which is highly polished aluminum. The grooves provide a little cushion of air for the head when it is spinning. This little air cushion reduces the tension on the tape. The video tape slides smoothly without

Figure 12.1. If you turn the upper video drum assembly (left) upside down (right) you get a clear view of the video heads.

Figure 12.2. The surface of the drum has a series of tiny lines or grooves all around it.

any jitter. If the video head is still good but the grooves are worn out, the head will need cleaning every time the machine is used. After a couple hours of playback use, the picture suddenly gets lost. You clean the head, and you get the picture back. In another few hours, the head gets dirty again. If this happens, the video head assembly needs to be replaced.

One sure sign that you have a problem with the video head is a picture that is complete noise (**Figure 12.3**). We had such a problem with a Minolta Master Model 8-418 8 mm camcorder. We first tried cleaning the head with a cleaning tape. This didn't work. Then,

we used a chamois swab. The technique for doing this was shown earlier in the book in **Figure 6.5**. This didn't help either. Then, we tried adjusting the tape guides to obtain a picture. We didn't have any luck with this either. Finally, after closely inspecting the head with a magnifying lamp, we concluded that the head was damaged and needed to be replaced.

12.2 Replacing Video Heads

If a video head is found to be defective, you have to change it. This is comparatively easy. There are only two ways to place a video head in a camcorder, the correct way and 180 de-

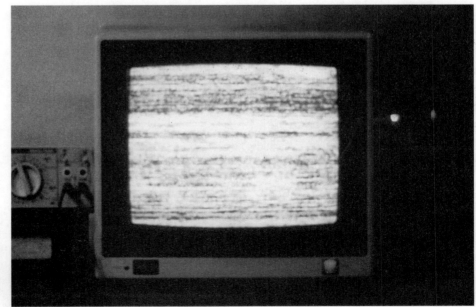

Figure 12.3. One sure sign that you have a problem with the video head is a picture that is complete noise.

grees out of alignment. If you have a 5-head machine, you need to be sure that the new head aligns in the machine the same way as the old head.

In most camcorders, the video head is attached to the shaft with only two screws. Marking the shaft and the old drum will help you put in the new part correctly. The disassembly procedure starts by removing a metal bracket over the video drum (not every drum has this piece). This bracket is a grounding plate that prevents the buildup of static electricity (**Figure 12.4**). Next, you must remove the two screws that secure the upper video drum to the rest of the assembly (**Figure 12.5**). Then, you have to desolder the wires that go to the head. On some

camcorders, this final step is not necessary. Connectors from the transformer on the bottom of the video head have pins that go to the video head printed circuit board. These heads fit into the machine only one way.

After you desolder the wires from the heads, you have to pay close attention to the colors of the wires. You don't want to reverse the wires when you resolder them to the new head assembly. At this point, you can remove the old head. Before you seat the new head, make sure that it is clean, no lint, dust or debris. Put the head assembly in carefully, gently pressing it down. Don't force it or bend it. When it is seated correctly, screw in the two screws and make sure you tighten them.

Figure 12.4. The grounding plate, which prevents the buildup of static electricity, is removed first when replacing a video head. *Reproduced with the permission of Matsushita Electric Industrial Company Ltd.*

Figure 12.5. You must remove the two screws that secure the upper video drum to the rest of the assembly; then, you have to desolder the wires that go to the heads. *Reproduced with the permission of Sharp Electronics Corporation.*

No further alignment is necessary. Once the head is put in properly and the screws tightened, there is no need for further alignment. You may now align the tape guides, if necessary, but you don't have to align the video head.

Once you install the new head, you should check the picture, to make sure you are not getting lines at the bottom of the screen. Then, you should check the alignment of the left and right tape guides. You have to be able to play any tape recorded in another machine with only a minor adjustment of the tracking control. If a camcorder has automatic tracking, it has to be able to play any tape recorded on any machine (unless the machine that recorded the tape is out of alignment).

To return to our story about the Minolta camcorder: After deciding that the video head was bad, we were prepared to replace it in the manner just described. We called up Minolta to find out the cost of a replacement assembly and were shocked at the price—$229! This part usually is expensive, but in the $75 to $100 range. This high cost signaled the end to this repair since the owner of the camera was not willing to pay the price for the part plus labor.

Later, we realized why the part is so expensive. In the Minolta camcorder, the video head cannot be removed as described above. Instead, the entire drum assembly must be replaced as one piece (**Figure 12.6**).

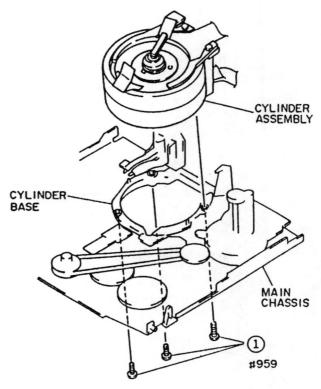

Figure 12.6. The entire drum assembly of the Minolta Master 8-418 must be replaced as one piece.
Reproduced with the permission of Minolta Corporation.

Troubleshooting the DC-DC Converter

As already mentioned, a camcorder works on battery power and, therefore, does not include a traditional power supply within its electronics. AC adapters, which sometimes are used to power camcorders, are separate units, and not part of the camcorder circuits.

Though a battery may provide 6 or 12 DC volts to the camcorder, other DC voltages are needed by the various parts of the camcorder. The module that supplies these different voltages is the DC-DC converter. In this chapter, we explain how to troubleshoot the DC-DC converter in the RCA PRO843 8 mm camcorder.

Figure 13.1 shows the schematic diagram of the DC-DC converter in the RCA. You may suspect a problem with the DC-DC converter if the voltages shown at connectors CN901 and CN902 are missing. If this is the case, the first thing to check is the condition of the battery and whether or not it is plugged in correctly. Check the battery for correct voltage and check if it is making good contact with the terminals at the rear of the camcorder.

If the battery appears to be okay, the next step is to check the fuses, PS901 and PS902. A continuity check can be made with a DMM set to the ohms setting. If you find a bad fuse, change it and retest. If the fuse blows again, you have to continue testing.

This DC-DC converter employs a step-up transformer T901. You should check for voltages on the primary and secondary sides of the transformer. If voltages are missing on the primary side, check resistor R19, capacitor C912, and transistor Q907. If all these appear to be in good condition, check the input voltages on pins 3, 6, 9, 12, and 15 of IC901. If all these voltages are present, IC901 is probably the culprit.

If you find voltages on the primary but not the secondary side of the transformer, the transformer probably is bad.

If voltages are present on both sides of the transformer, check transistors Q910, Q912, Q913 and Q914. If these are good, check diode array D907 and potentiometer VR903. If these are good, check the solder joints at connectors CN901 and CN902.

Figure 13.1. Schematic diagram of the DC-DC converter in the RCA PR0843.

Chapter 14

Operation of the Camera Circuits

Modern camcorders employ sophisticated electronics to provide the many automatic features users have come to expect. This chapter describes the electronics of the Minolta Master 8-418 8 mm camcorder to give you some idea of how the features are implemented.

The electronics of this, and most other palm-sized camcorders, are miniaturized and very reliable. Most major functions are handled by one or more ICs. Digital signal processors, which are flexible programmable ICs, are increasingly used to perform specific tasks.

If you become convinced that a camcorder has a problem with its electronics, keep in mind that modern camcorders are modular. If you can isolate the problem to a certain area of the camcorder, you may be able to replace the module to solve the problem.

Figure 14.1 shows a block diagram of the camera circuits of the Minolta 8-418 camcorder. This chapter explains the functions of the 14 ICs that make up the camera's signal processing unit.

The CCD (Charge Coupled Device) color image sensor (IC1001) is a 1/3" interline type sensor. It converts incoming light from the subject to a video signal. The CCD is shown in **Figure 14.2**.

The automatic iris driver (IC1002) drives the iris motor to control the iris opening. The F-value detector (IC1003) supplies bias current to the Hall device and detects the F-value. The vertical driver (IC1201) generates four phase-shifted vertical clock pulses and drives IC1001.

The CDS/AGC circuit (IC1202) processes a continuous signal and attenuates noise generated by the CCD sensor to improve the signal-to-noise ratio. This IC also controls the gain of the input signal so that the input sig-

nal applied to the analog-to-digital converter is constant. The gain control is performed by the state data supplied from the digital microprocessor, D-μP.

The sensor driver (IC1203) drives the CCD sensor and controls the shutter speed. This IC is also controlled by the D-μP. An A/D (analog-to-digital) converter (IC1204) converts the analog signal to 9-bit digital data.

The zoom motor driver (IC1207) drives the zoom motor located on the autofocus/lens block. The electronic zoom (IC1208) performs zooming in and out. The zooming ratio for this camcorder is set to 16X to 64X.

The reset circuit (IC1209) initializes IC1210. Digital microprocessor D-μP (IC1210) communicates with the sub-system control microprocessor, S-μP, and controls IC1203, IC1208 and IC1213. EEPROM (Electrically Erasable Programmable Read Only Memory) IC1211 holds in its memory state data, adjustment data and other information.

D/A (digital-to-analog) converter IC1212 converts 8-bit digital luma and chroma signals to their analog counterparts and supplies them to the luma/chroma circuit.

This camcorder employs a digital signal processor (DSP) for camera signal processing. Through the use of a DSP, the automatic iris and white balance are controlled by artificial intelligence to enhance color reproduction.

The DSP (IC1213) delays the input signal by 2H (Horizontal line), processes 3H, extracts the luma and chroma signals using filters, and processes the luma signal (horizontal and vertical enhance, gamma correction, etc.).

Additionally, the DSP encodes the signal, matrixes the signal to generate R/G/B 3-color primary signals, processes the chroma signal

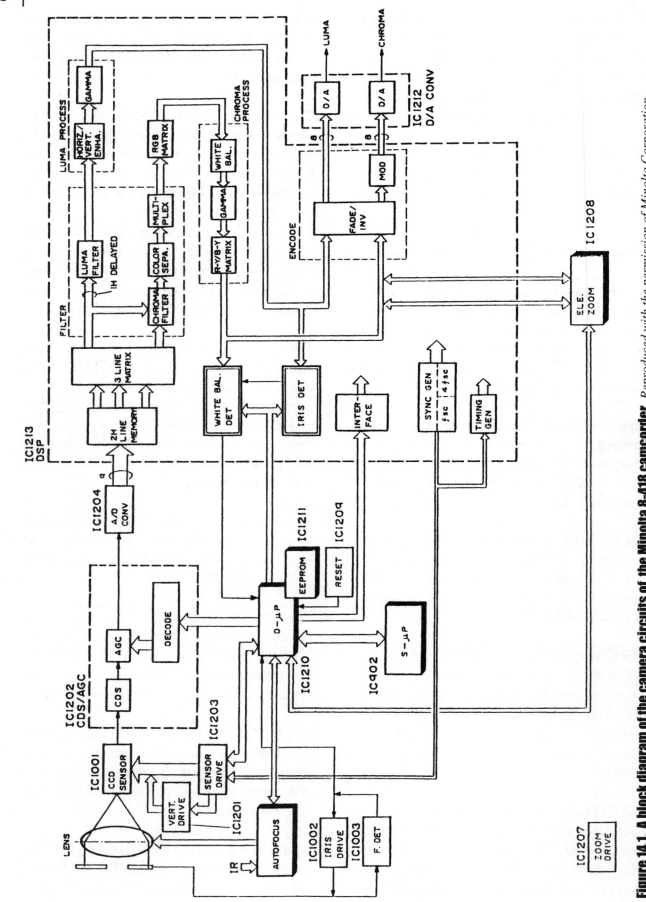

Figure 14.1. A block diagram of the camera circuits of the Minolta 8-418 camcorder. *Reproduced with the permission of Minolta Corporation.*

(white balance, gamma correction, color difference signal matrixing, etc.), controls the iris opening, and controls the white balance. The DSP also generates sync pulses and timing pulses for processing the signal by a sync generator and timing pulse generator.

The automatic focus control circuit controls the focus lens using reflected infrared rays from the subject.

Though the camera circuits of a camcorder are technically complex, repairing them need not be. As demonstrated in Appendix A: Case Study 1, the JVC GR-AX7U apparently had a problem with its CCD since it was not delivering a picture in camera mode. This was not the case, though. Instead, one of the connectors on the VTR board of the camcorder had a cracked solder joint. Thus, it was the interconnection rather than the component that was causing the problem.

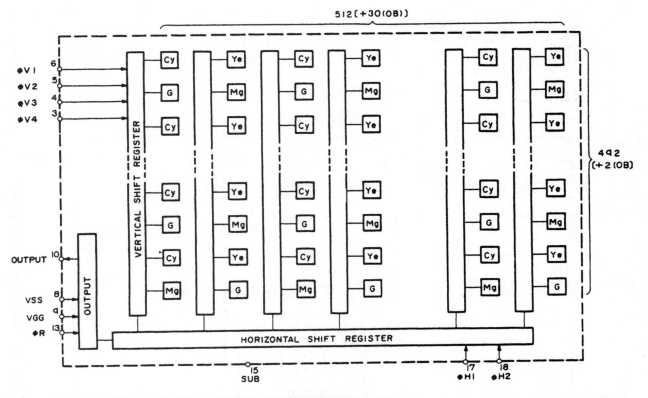

Figure 14.2. The CCD (Charge Coupled Device) color image sensor. *Reproduced with the permission of Minolta Corporation.*

Operation of the System Control Circuits

In the Minolta Master 8-418 camcorder, two microprocessors are used for system control: the main system control microprocessor (M-μP) and the sub-system control microprocessor (S-μP). This chapter describes the functions of these two microprocessors (**Figure 15.1**).

15.1 The Main System Control Microprocessor (M-μP)

When power is supplied to the camcorder from a 6-volt battery or AC adapter, the main system control microprocessor becomes energized and performs the functions outlined below.

Receives data from the eject and power switch inputs, short-circuit detection input, and the presence or absence of a battery connected to control power on and off.

Transfers the overdischarge detection reference voltage and switching point to the EAROM (IC905) in the test mode and the slow tracking data and artificial V.SYNC (Vertical Sync) phase data during power off. It reads the data when the power is turned on.

- Receives the battery terminal voltage, measures it, and converts it to display data. It detects short-circuits to protect circuits.

- Transfers commands and function data to the luma signal processing circuit (IC101).

- Monitors the outputs of the sensors in the mechanism to detect the type of cassette, opening or closing of the cassette holder, and the operation states of motors and the tape transport.

- Detects connection of the A/V IN/OUT connector (JK001).

- Receives operation key data supplied to JK001.

- Controls the loading motor to switch the operation mode of the mechanism.

- Detects the amount of tape transported when pause is pressed during recording so the amount of overlap is held to a minimum. It also controls the bias oscillation (on/off) of the flying erase head.

- Switches the operation mode (recording or playback) of the head switching circuit (IC104) of the video heads.

- Controls the video and audio outputs.

- Controls the pilot signal selection during recording and playback.

- Receives the CAPST.FG (Capstan Frequency Generator) signal and ATF error voltage to control the capstan servo.

- Receives the CYL.FG (Cylinder Frequency Generator), PG (Phase Generator), and V.SYNC signals to control the cylinder servo.

- Generates an artificial V.SYNC signal during trick play and applies it to the video output.

- Generates a SW30Hz (30 Hz Switching) signal from the PG signal and uses this to time the start of recording and erasing.

- Communicates operation data and backup data with the S-μP via communication lines.

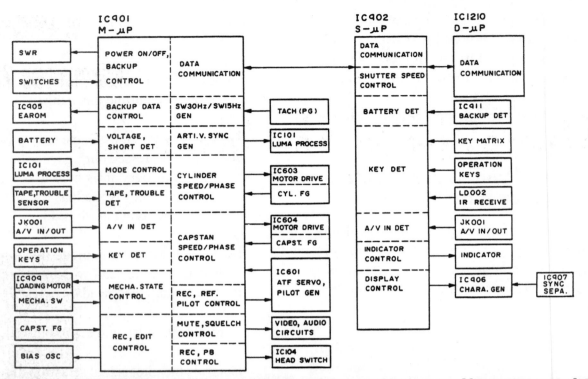

Figure 15.1. In the Minolta Master 8-418 camcorder, two microprocessors are used for system control: the main system control microprocessor (M-μP) and the sub-system control microprocessor (S-μP). *Reproduced with the permission of Minolta Corporation.*

15.2 The Sub-System Control Microprocessor (S-μP)

When power is supplied to the camcorder from a 6-volt battery or AC adapter, the sub-system control microprocessor (IC902) becomes energized and performs the functions below.

•Transfers data on the positions and functions of the operation switches to the M-μP through communications lines and receives data of the operation mode from the M-μP. The S-μP also communicates with D-μP in the camera block, transferring operation and function data and receiving display data.

•Detects the power or backup mode by a backup detector (IC911) and maintains information for data, time, tape counter and so forth.

•Controls the shutter speed.

•Transfers character and display position data to a character signal generator (IC906).

•Detects switch inputs from direct operation key inputs and the infrared receiver (LD002).

•Drives the tally indicator.

15.3 Troubleshooting the Microprocessors

It should be obvious by now that the microprocessors in this and other camcorders do a lot of work. If a camcorder is acting erratically, it may be due to a faulty microprocessor, but this is not very likely. Microprocessors are very reliable. The cause is more likely to be one of the inputs to the microprocessor such as a switch or sensor. Make sure to check that these are working properly before you blame the microprocessor for the problem.

Operation of the Servo Circuits

16.1 Servo Circuit Operation

During recording, the servo circuit makes the magnetic tape run at precisely the specified speed (1.4345 cm/s) needed to maintain the specified video track pitch (20.5 mm). This circuit also rotates the video heads accurately at the rated speed (1,800 rpm) to keep the length of video tracks constant. Additionally, it matches the position of the rotary video head precisely with the phase of the vertical sync signal in the video signal to be recorded. This aligns the starts of video tracks at positions 6H before the vertical sync signal.

During playback, the servo circuit aligns the recorded video track precisely with the scanning of the video heads while rotating the heads accurately at 1,800 rpm.

For this type of control, speed and phase controls are applied to the capstan motor, which drives the tape, and the cylinder motor, which drives the rotary video heads. The speed control maintains a constant relative speed between the rotary video heads and the video tracks. The phase control optimizes the tracking. **Table 16.1** shows the reference and feedback signals used for each control.

1/2V.SYNC Signal

This is a reference signal for cylinder phase control during recording. It is obtained by dividing the vertical sync signal (separated from the video signal) by two.

REF.30Hz Signal

This is a reference signal for cylinder phase control during playback. It is obtained by dividing the 16 MHz system clock pulse down to 30 Hz.

REF.210Hz Signal

This is a reference signal for capstan phase control during recording. It is obtained by dividing the 16 MHz system clock pulse down to 210 Hz.

Motor	System	Mode	Reference Signal	Feedback Signal
Cylinder	Phase	Recording	1/2V.SYNC	PG
Cylinder	Phase	Playback	REF.30Hz	PG
Cylinder	Speed	Common	Cylinder FG (CYL.FG: 720Hz)	None
Capstan	Phase	Recording	REF.210Hz	Capstan FG (CAPST.FG/4: 210Hz)
Capstan	Phase	Playback	4-frequency pilot	None
Capstan	Speed	Common	Capstan FG (CAPST.FG: 840Hz)	None

Table 16.1. Signals used in the servo system.

PG (Phase Generator) Pulse

This is the feedback signal for cylinder phase control. It is generated from a magnetic sensor on the FG sensor circuit board attached to the lower cylinder. This sensor detects the passing of the magnet installed approximately 100° before the CH2 video head on the upper cylinder. The frequency of the PG pulse is 30 Hz when the cylinder motor rotates at 1,800 rpm.

Cylinder FG (Frequency Generator) Pulse

This signal (CYL.FG) is used to detect the speed of the DD (Direct Drive) cylinder motor. It is generated from the FG sensor circuit board attached to the lower cylinder. This board detects the passing of a magnet fitted to the rotor shaft of the DD cylinder motor. The frequency of the CYL.FG pulse is set as follows:

Recording/Playback	720 Hz
Still Play	716 Hz
Forward Search	742 Hz
Reverse Search	697 Hz

Capstan FG Pulse

This signal (CAPST.FG) is used to detect the speed of the DD capstan motor. It is divided by four to generate a feedback signal for capstan phase control during recording. This pulse is generated from an FG sensor attached to the chassis. This sensor detects the passing of a magnet fitted to the rotor shaft of the DD capstan motor. When the rated tape speed is maintained, the frequencies of the CAPST.FG pulse are set as follows:

Recording/Playback	840 Hz
Forward Search (X9)	7,785 Hz
Reverse Search (X7)	5,700 Hz
Fast Forward (X15)	13,298 Hz
Rewind (X15)	11,861 Hz

4-Frequency Pilot Signals

These signals are the feedback signals for capstan phase control during play. One of the 4-frequency pilot signals is selected. It is synchronized with the head switching signal (SW30Hz) in the specified order for each field during recording and is recorded together with other RF signals. During playback, the main RF signal component and the pilot signal components from adjacent tracks are reproduced by the rotary video heads. The frequencies of the pilot signals are specified as:

f1	6.5fH
f2	7.5fH
f3	10.5fH
f4	9.5fH

f1 and f3 are recorded by the CH1 video head and f2 and f4 by the CH2 head. The frequency of the clock pulse for generating pilot signals is 5.947452 MHz (378fH). The specified ATF (Automatic Track Finding) servo system is used for phase control of the capstan motor during playback.

In the Minolta Master 8-418 camcorder, the servo circuit consists of six ICs (IC901 and IC601 to IC606) as shown in **Figure 16.1**.

The main system control microprocessor (IC901) controls the speed and phase of the cylinder motor during recording and playback, the speed of the capstan motor during recording and playback, and the phase of the capstan motor during recording.

The automatic track finding (ATF) servo circuit (IC601) controls the phase of the capstan motor during playback using recorded pilot signals. It also generates the pilot signals, recording and reference, during recording and playback.

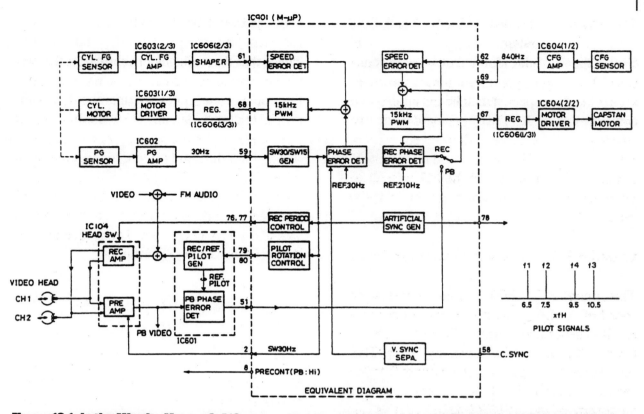

Figure 16.1. In the Minolta Master 8-418 camcorder, the servo circuit consists of six ICs (IC901 and IC601 to IC606). *Reproduced with the permission of Minolta Corporation.*

The amplifier (IC602) amplifies the PG pulse. One of the motor drivers (IC603) drives the cylinder motor and amplifies the CYL.FG pulse. The other motor driver (IC604) drives the capstan motor and amplifies the CAPST.FG pulse.

The shaper (IC606) amplifies the CYL.FG pulse and regulates the PWM (Pulse Width Modulation) signal generated by the M-µP with the switching regulator (SWR).

16.2 Servo Circuit Troubleshooting

As with other camcorder electronics, the servo circuit is very reliable. One possible problem you may encounter is with the speeds available on the camcorder. Sometimes the camcorder has trouble determining the correct speed to play (SP/LP/EP). This happens when the audio head (on camcorders that have a separate audio head) is not mounted properly. The audio head is often mounted on the same assembly as the control head, which reads the information on the control track. If the audio head is misaligned, the control head will be too. The camcorder cannot read the information on the control track of the tape and thus has a problem determining the correct speed, which is recorded on the control track. Head alignment is essential for keeping proper speed.

Motors, which are controlled by the servo system, may burn out, but this is not a usual occurrence. If a motor dies, the camcorder will shut off as soon as it senses that the drum or capstan motor is not turning. Before you decide that a motor is bad, make sure to check that the battery or AC adapter is providing the motor with sufficient voltage and that the microprocessor is sending the signal to start the motor.

Sometimes a motor drive IC will go bad. Evidence of this problem, as you might guess, is erratic speed of the motor that is under control. For example, you might notice the video drum changing speeds, instead of running at a constant speed. It is always a good idea to make as many measurements as you can before deciding to replace an IC. Make sure to check that the voltages (as shown in the service manual) are correct. If you have an oscilloscope, you can check whether the IC has appropriate control signals at each pin.

Operation of Camcorder Video

When a camcorder is in the record mode, the video signal produced by the camera section is separated into luma (brightness) and chroma (color) signals. These signals are then processed by luma and chroma processors in order to "fit" the video information on the video tape. These two components are also combined into a standard video signal, so that you may view the signal in the electronic viewfinder as you are recording it.

During playback, the luma and chroma processors reverse the procedure, taking the chroma and luma information from the tape, rebuilding the video signal, and then sending it to the electronic viewfinder.

The video section of the Minolta Master 8-418 consists of six ICs (**Figure 17.1**). The luma signal processing circuit (IC101) consists of recording and playback circuits for the luma signal provided by the camera section of the camcorder. This IC also adds the INFOS character signal generated by a character signal generator (IC906) to the recording and playback signals. If an external video signal is supplied to the A/V IN/OUT connector (JK001), IC101 provides a comb filter to separate the luma and chroma signals. The operation mode is controlled by the main system control microprocessor.

The chroma signal processing circuit (IC102) consists of recording and playback circuits for the chroma signal provided by the camera section of the camcorder. Together with IC101, it creates a feedback type comb filter that attenuates crosstalk components from adjacent video tracks.

The head switching circuit (IC104) consists of recording amplifiers and preamplifiers and supplies the recording current to the CH1 and CH2 video heads. It also produces a continuous signal during playback.

The CCD 1H delay circuit (IC105) delays the input signal by 1H for the comb filter and provides dropout compensation.

The character signal adder (IC108) adds the date character signal to the camera luma signal during recording.

The input signal selection circuit selects the input signal depending on the mode, recording or playback.

As with all of the other electronic circuits in the camcorder, the video circuits are very reliable. If video is not present during record mode, check to see if you can play a tape that has been previously recorded. If you can, then the video circuits are working and the camera section is at fault.

Remember, too, that many of the mechanical problems in a camcorder translate into distorted video. Noise, jumping frames and tearing are not symptoms of malfunctioning video circuits. Look instead for dirty video heads, poor tape tension and tape guides that are out of adjustment.

The Appendices that follow describe seven actual case studies of camcorder repairs. If we haven't done so already, these case studies should give you a clear idea of what goes wrong with camcorders and how to fix them.

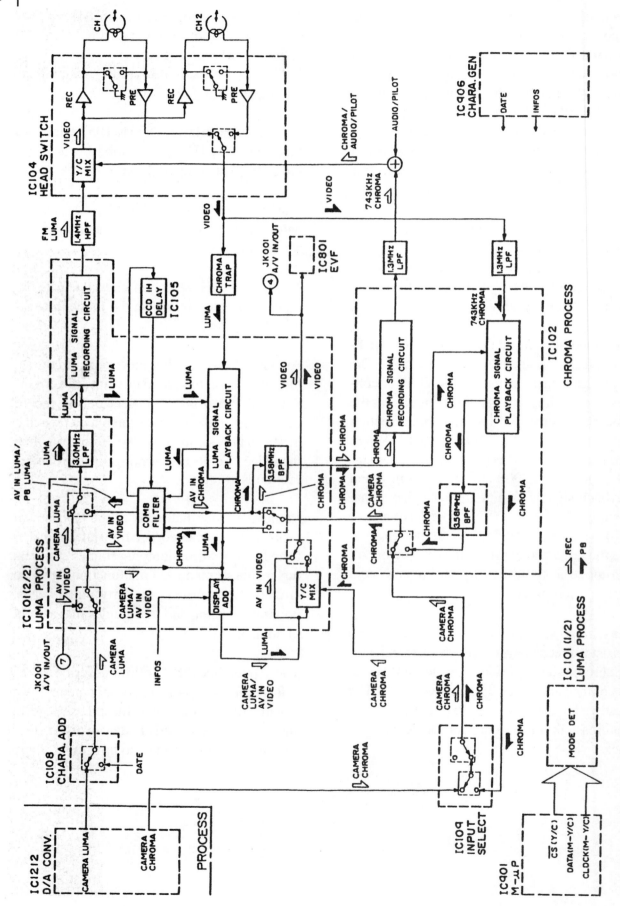

Figure 17.1. The video section of the Minolta Master 8-418 consists of six ICs. *Reproduced with the permission of Minolta Corporation.*

Case Study 1: JVC GR-AX7GYU

This VHS-C-format camcorder had a problem taking pictures. In other words, when you pointed the camera lens at a subject, nothing appeared in the viewfinder—only a blank screen. The VCR part of the camcorder, however, was working perfectly. If you placed a prerecorded tape in the machine and pressed play, the picture immediately appeared in the viewfinder.

The component responsible for producing the image you see in the lens is called the CCD sensor or charge coupled device. The CCD converts light into electrical charges. (In older cameras this was done with a color pickup tube such as a Saticon or Newvicon.) We assumed that this component was causing the problem. Either the sensor had failed, or it wasn't getting power from the power supply, or at some point in the circuitry there was a broken connection. We thought a broken connection was the most likely cause of the problem since the owner of the camera told us he had accidentally dropped it. Now, it was up to us to find the broken connection.

We began the disassembly by removing the cassette door. This is not as easy to do for this camcorder as it is for some others. In this camcorder, the door has numerous button controls and is connected to the main chassis through a flexible ribbon cable. We removed the screws and unclipped the cable.

Next, we unscrewed the microphone assembly, which includes the recording light, and disconnected the wires. At this point, we removed the screws from the operation panel at the top of the camcorder and carefully disconnected the wire that connects it to the main chassis. Next was the viewfinder. We removed two screws and disconnected it from the rest of the camcorder.

We continued the disassembly by removing the back of the camcorder, where the battery clips on. Finally we removed the remainder of the case. Now, we were left with just the circuit boards, mechanism and lens. In this camcorder, there are several small PC boards, which surround the lens, and a larger PC board, called the VTR board, which lays on the mechanism assembly. The smaller boards and the lens can be removed in one piece from the VTR board. **Figure A.1** shows how all these pieces fit together.

To separate the mechanism assembly from the circuit boards and lens, you first have to disconnect the lens and its surrounding circuit boards (as one piece) from the VTR board. Next, you must unscrew two tiny screws that secure the VTR board to the mechanism assembly. Once you remove these two screws and a ribbon cable, you can separate the VTR board from the mechanism assembly.

Now, we were just about ready to take some measurements. Before you can make any measurements, you have to reattach the lens and its surrounding boards to the VTR board. Then, you have to connect the rear cover of the camcorder, which contains the battery terminals, and the control board. We attached the bench power supply to the battery back and turned on the power.

We wanted to check the DC-DC converter to see if it was producing the voltages needed for the CCD. We had to purchase the service manual to find out what the voltages were and where to check. The DC-DC converter produces three voltages, 12 V, 5 V and -8 V. We checked for them at the point where the DC-DC converter board connects to the VTR board. All the voltages were there.

Next, we decided to check if the CCD was delivering a signal. The service manual shows a test point TP1 on the small board that holds the CCD. In trying to locate this point, we disconnected all the small PC boards around the lens. We finally found TP1 in the middle of the CCD board facing the lens. To be able to test this point with a scope, we soldered a wire onto the metal piece labeled TP1. Then we reassembled all the small PC boards around the lens, connected this unit to the VTR board and powered it up. We did not get any signal at TP1. Now, we had to investigate whether this was due to a faulty CCD sensor or not.

To check whether a broken connection might be causing the problem, we put some pressure with our fingers in different spots, all the while watching the scope. Suddenly, we saw a waveform appear. We quickly attached the viewfinder to the VTR board and took a look. Sure enough, there was a picture in the viewfinder. The picture was sharp and focused—a picture of our workbench! But, the moment we released the pressure the picture disappeared.

The whole lens assembly including all the small PC boards, is connected to the VTR board through two sockets. We suspected that one of the sockets was causing the problem. The larger socket is underneath the lens as-sembly; we had no access to it while the assembly was in place. The smaller one is at the edge of the VTR board. We put pressure on this small socket and immediately the waveform reappeared on the scope. We were now fairly certain that this socket was the cause of the problem. This socket has two rows of pins. We resoldered the pins facing outward, but this didn't help. So, we disconnected the lens assembly to get at the pins that were facing inward.

Soldering these pins is very difficult because they are very closely spaced and there are many other components in the area. We used a 10-watt soldering iron with a sharp tip for the job. Even with this fine tip, we bridged two of the pins. We removed the extra solder with a solder wick. When we were satisfied with the resoldering job, we began the long process of reassembling the camcorder.

When we got to the point where mechanism, VTR board, lens assembly, operation panel, viewfinder and rear cover were in place, we inserted a cassette and pressed record. Everything seemed to be working, so we continued until we finished reassembling the camcorder. It's a good idea, anytime you are reassembling a camcorder to try out the different parts as they go together, to make sure everything is still working.

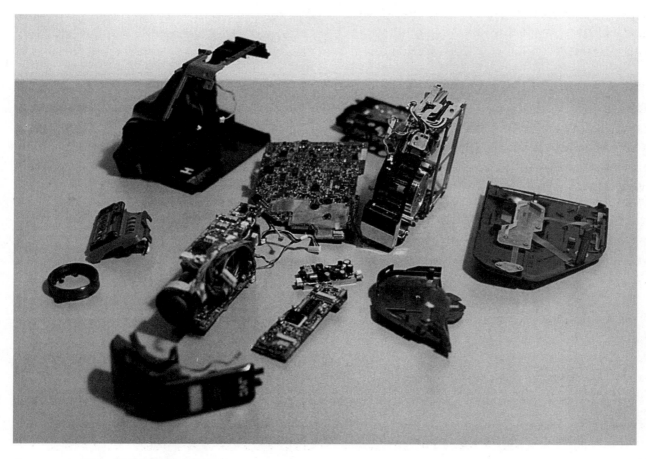

Figure A.1. Circuit board locations.

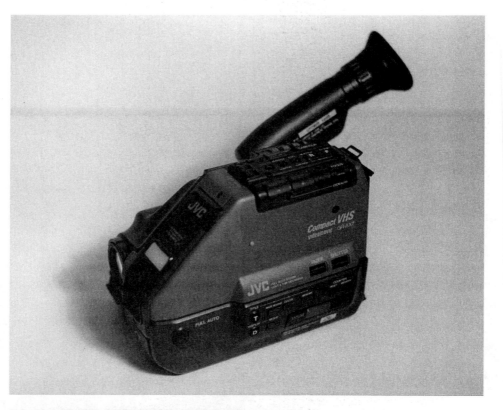

A.2. The JVC GR-AX7GYU VHS-C format camcorder.

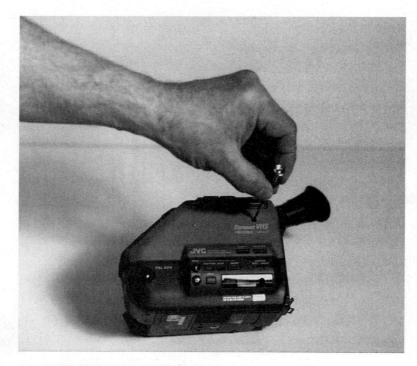

A.3. Unscrewing the cassette cover.

A.4. Removing the microphone assembly.

A.5. Removing the operation panel.

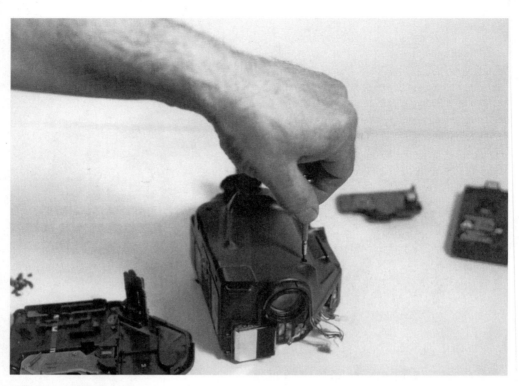

A.6. Unscrewing the case.

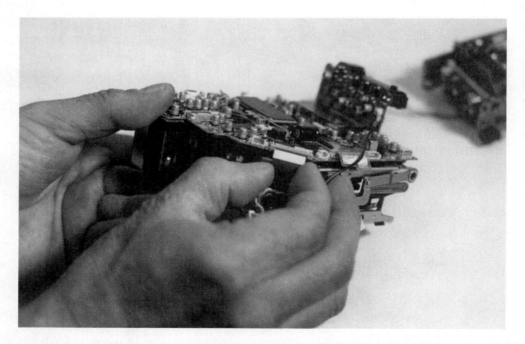

A.7. After removing the lens assembly, removing the flexible cable that connects the mechanism assembly to the VTR board.

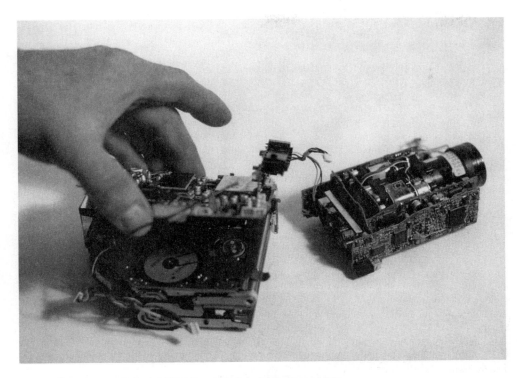

A.8. Lifting the VTR board off the mechanism assembly.

A.9. The lens and its surrounding PC boards lies next to the VTR board and rear cover.

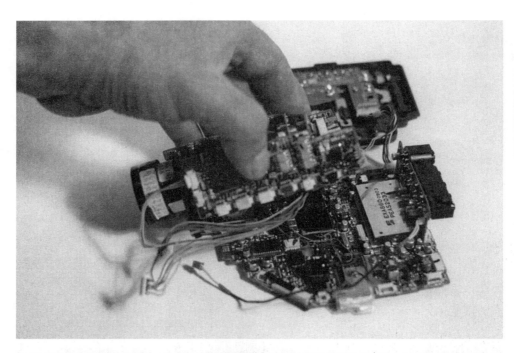

A.10. Connecting the lens assembly back to the VTR board prior to taking voltage measurements.

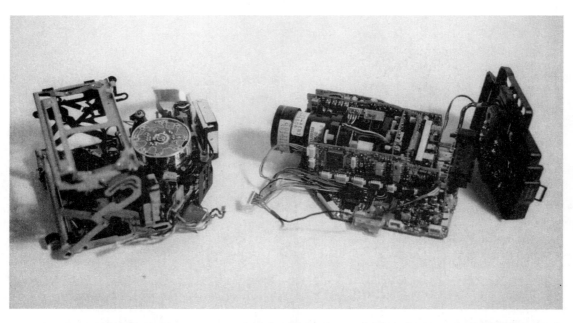

A.11. The lens assembly, VTR board and rear cover are now ready for testing. The mechanism assembly is completely disconnected and not needed during testing.

A.12. With 6 VDC connected to the rear cover (power supply not shown) the meter
shows that the DC-DC converter is producing 12 volts.

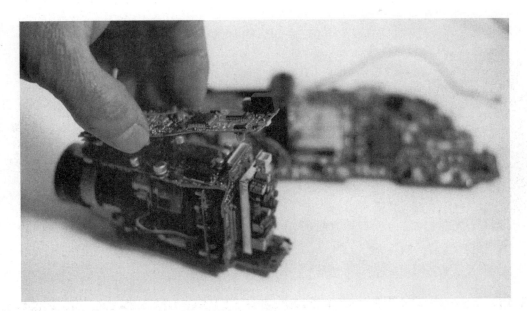

A.13. Removing the video board from the lens assembly.

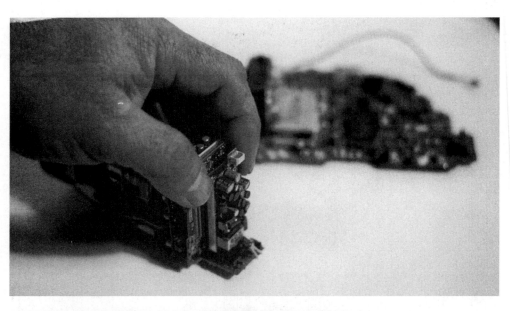

A.14. Removing the DC-DC converter from the lens assembly.

A.15. Removing the CPU board from the lens assembly.

A.16. The CCD produces the picture for the camera. At first, we thought this chip was the culprit.

A.17. Soldering a wire to TP1 to check the CCD.

A.18. We had to do a partial reassembly to test the CCD. Note the scope probe in the upper right corner of the picture.

A.19. After applying pressure to several of the boards, a waveform appeared on the scope. This indicated that there was a broken connection rather than a faulty CCD.

A.20. The cause of the problem was one of the connectors. We resoldered all the connections with a 10-watt iron with a sharp tip.

A.21. After noticing a solder bridge that we had inadvertently created, we used solder wick to get rid of it.

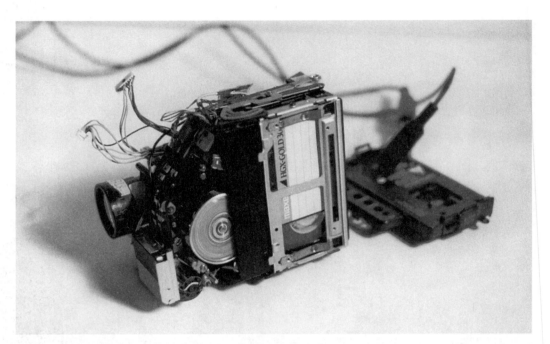

A.22. During the reassembly of the camcorder, we stopped to check if the recording feature was working—before putting the covers back in place. Fortunately, everything was now working fine.

Appendix B

Case Study 2:
Panasonic PV-IQ545D

The symptom of the problem with this camcorder was a loss of sound. To test the camcorder, we connected it to a composite video analog monitor, using a special cable. This cable has a proprietary connector on one end and video and audio RCA jacks on the other.

This camcorder is a VHS-C model. We put a recorded tape into the camcorder and pressed the play button. The picture came on right away but the sound was missing. Instead, we heard a low humming noise. This low noise indicates that the sound amplifier is in working condition. We now had to find the point where the audio signal was dropping out.

The first thing we did was remove the cassette tape and make a thorough visual inspection of the mechanical parts of the camcorder. We were looking for any obvious signs of distress or missing parts, such as bent or broken tape post guides. Keep in mind that camcorders typically take a lot of abuse. There is a good chance that a part may be broken or bent or otherwise out of alignment.

In this camcorder, the audio is read from the tape by a separate audio head, which is mounted just before the capstan shaft. From this point, the audio is amplified by the audio circuits and then fed to the output jack. In this camcorder the audio output jack is the same jack used for the video output.

This particular camcorder does not have 2-channel stereo sound. It has monaural sound, which is not even hi-fi. This is why there is a separate audio head.

To find out what was causing the problem with the sound, we first took the tape out of the camcorder. Then, we removed the plastic door that covers the cassette housing. Next, we placed a rubber tube over the LED that activates the tape sensors. Then, we pushed the housing down and pressed the play button. Since we had "fooled" the camcorder by defeating its sensors, the camcorder went into play mode without the tape.

To check the sound, we placed a small screwdriver near the front of the audio head without touching it. We moved the screwdriver in the direction the tape would be moving. We did this a few times with short strokes. We heard a loud noise. This indicated that the audio head, amplifier and everything else in the audio circuits were working.

We removed the rubber tubing and put the tape in again. When we pressed the play button, we noticed a problem with one of the tape guides. One tape guide, which was supposed to move the tape against the audio head, was not traveling to its final position. We pushed the tape guide slightly with a plastic rod (don't use a metal screwdriver to do this) and the sound came on loud and clear. We now knew that this tape guide was causing the problem. Somehow, this tape guide had been bent, probably from inserting a tape too quickly.

In a case like this, you have straighten up the tape guide. Use a reference, such as the capstan shaft. You have to view the two from a certain angle to see if they are both at the same angle. If you can straighten the guide the tape will play correctly. But, to do this alignment properly you have to disassemble the camcorder. You can do the alignment with a small screwdriver—no special tool is required.

Disassembling the camcorder is a time-consuming and tedious job. We counted sixteen different size screws just to take off one side of the cover. Plus, we still had to remove the other side! After removing a few more screws we were able to get the chassis of the camcorder out of the cover. We had some difficulty finding the final screw, since it was buried under the lens. To get at this screw, we had to push the lens to the side.

At this point, we had a full view of the mechanical assembly. Before you can do the alignment, you have to energize the loading motor. But, this cannot be done in the usual way since the outer case has been removed. To get the assembly to move, you have to apply a voltage directly to the loading motor. This is fairly easy if you have a regulated bench-type power supply. You apply 3 volts to the loading motor to initiate the loading procedure; then, you reverse the leads to perform the unload procedure.

By energizing the loading motor, you can watch as the tape guide moves along the track to its final position. In this case, the tape guide stopped about three-quarters of the way up the track. We reversed the voltage on the loading motor to get the tape guide back to its initial position. Then, we aligned the tape guide by bending it slightly with a small screwdriver. During this process, we made certain to use the capstan shaft as a guide to the alignment. When we were satisfied that the tape guide was correctly aligned, we energized the load-

ing motor again. This time, the guide moved along the track and did not stop until it was properly seated at the end of its run.

We put the tape in just to see if the tension of the tape had any effect on the guide. It didn't. We could see the tape now moved into its proper position against the audio head.

To do a final test, we needed to reassemble most of the camcorder. After this was done, we played the tape. Now, the sound came through loud and clear. All that was left to do was to finish reassembling the camcorder, which we did without any problems.

This repair, which seemed at first to be a electronic problem, turned out to be a pure mechanical repair. The repair probably took longer than it should have because this particular camcorder was so difficult to disassemble.

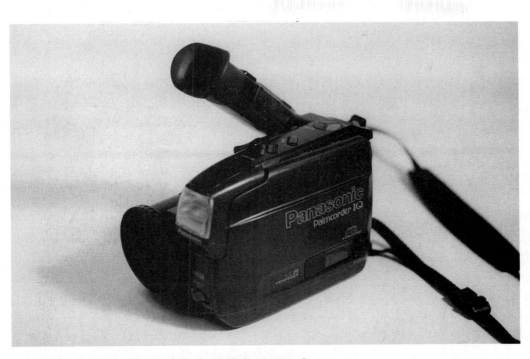

B.1. The Panasonic Palmcorder IQ VHS-C camcorder.

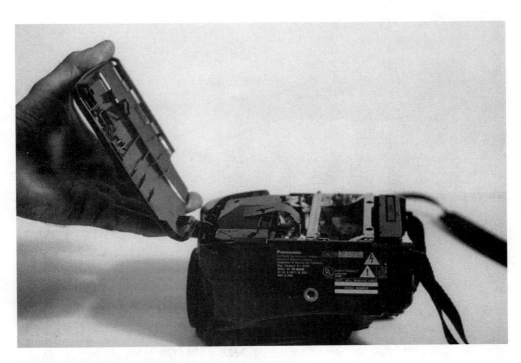

B.2. Removing the cover of the cassette housing.

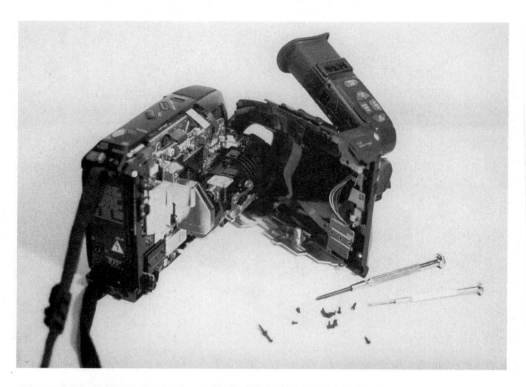

B.3. The camcorder had to be completely disassembled to reach the tape guide.

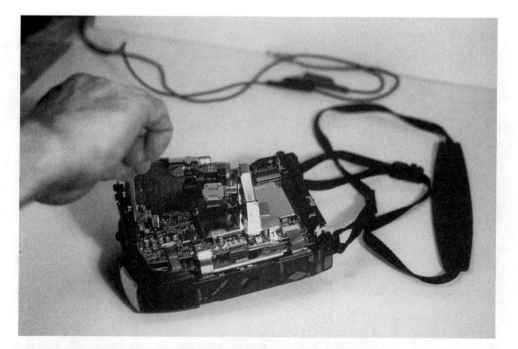

B.4. The most difficult screw to find was hidden under the lens. We had to move the lens to the side to reach the screw.

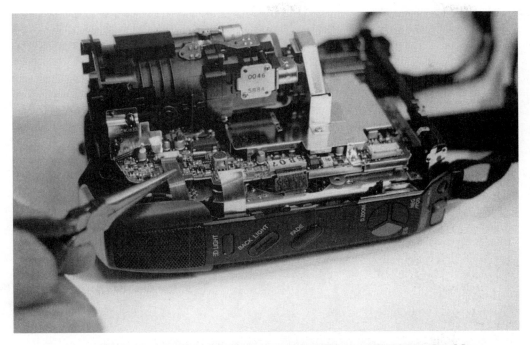

B.5. To remove the chassis from the case, you must disconnect several cables.

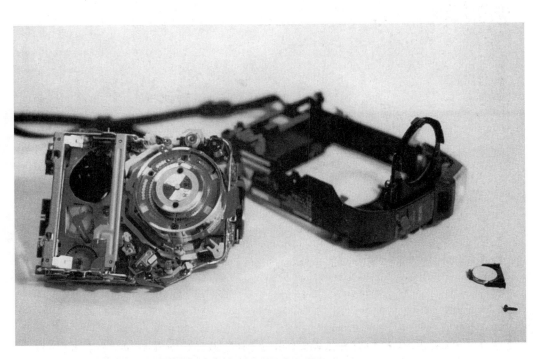

B.6. Here the chassis is completely removed from the case.

B.7. To move the tape guides, we powered the loading motor from our bench-type power supply.

B.8. A view of the tape guide stuck about three-quarters of the way up its track.

B.9. We brought the tape guide back to its initial position and realigned it using a small flat blade screwdriver.

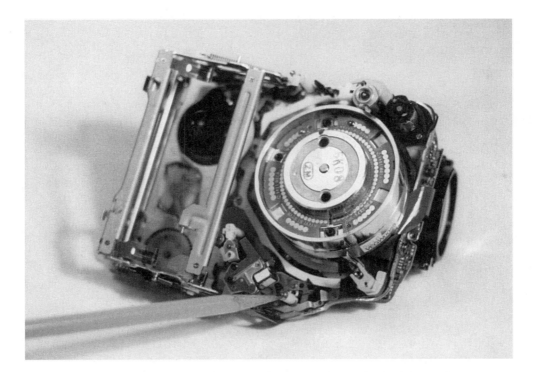

B.10. With the tape guide properly aligned, we energized the loading motor, and the guide moved to its final position.

Appendix C

Case Study 3:
Yashica Samurai KX-77U

The problem with this camcorder was distorted playback video. During playback, the picture in the viewfinder had a thick line on the bottom. Also, at times, the picture jumped and lost its sound.

To obtain a better view of this, we hooked up the camcorder to a composite video analog monitor. This connection is made from the RCA jacks on the side of the camcorder to the RCA jacks on the monitor. With an 8mm tape in the camcorder, we pressed the play button. Immediately, we saw a thick line at the bottom of the picture. We also noticed that the sound was fading in and out. This verified the description of the problem given to us by the customer.

This type of problem, which is mechanical in nature, is normally caused by misalignment of the tape. In a normal working camcorder, after the tape is loaded into the cassette housing and the play button is pressed, the right and left tape guides move forward to wrap the video tape around the video head. In this process, the height of each tape guide is critical to the quality of the playback video. Normally, the manufacturer presets the height of these tape guides, using a test tape. To make sure these guides will not change position over the course of time, each one has a lock screw. The lock screw, which can be adjusted with an Allen wrench, is located at the bottom of the guide.

Some manufacturers put a drop of lock tightener (a glue-like substance) on the screw so that it will never loosen. But, even with all these precautions, the screw may loosen anyway and an alignment problem occurs.

To reach the tape guide in this camcorder, all we had to do was remove the door of the cassette housing. Without removing anything else, we had enough room to adjust the tape guide with a special alignment tool.

During playback, a line at the bottom of the picture is usually caused by the right tape post (looking at the guides from the front of the mechanism). The right guide is always next to the pinch roller.

Using the alignment tool, we turned the tape guide about half a turn in the counterclockwise direction. Then, we placed the tape in the machine and played it to see how the picture looked. The line was significantly smaller but still there. At least we knew we were turning the tape guide in the proper direction. We removed the tape and turned the guide another half turn. Now, when we tested the camcorder, the picture was perfect.

As we turned the alignment tool, we could feel the resistance of the guide due to the lock screw. In our judgment, the screw was not tight enough to hold the tape guide in its new position. Sometimes, when you turn the guide, the resistance is strong enough (the screw is tight enough) to hold the alignment. In this case, though, we decided the screw needed to be tightened a bit more. To get at the screw, further disassembly is necessary.

We began the disassembly by removing the screws that secure the lens cover to the camera body. Then, we removed the cover. The lens cover has two small circuit boards attached to it. Each of these boards is connected to the main circuitry of the camcorder through a cable. One is a standard cable, which we popped off its connector. The other is a flat ribbon cable, which we carefully disengaged. We released the cable by pushing its connector to the open position with a flat screwdriver.

Next, we removed screws from the bottom of the camcorder, which held the side cover in place. After releasing another flat cable from its connector, we were able to lift off the side cover of the camcorder.

Now we had a perfect view of the tape guides. We tightened the screw on the tape guide we had aligned and then made sure the screw on the other tape guide was tight. Then, we reassembled the camcorder and tested it one more time. It worked perfectly.

One more point to note about this repair. The way we did this repair was a short cut in a sense. We used this method because the left tape post was perfectly aligned. If both were out of alignment, we would have had no other choice but to attach a scope to the FM test point, and use an alignment tape to do the alignment correctly. Of course, if you don't have to do this you shouldn't, since it takes more time.

Any time you complete an alignment, make sure you test the camcorder by playing tapes recorded in different machines. Check that you are getting a good picture without having to change the tracking significantly. This is, in effect, a compatibility test. Also, you should record a tape with the camcorder and play it in other machines.

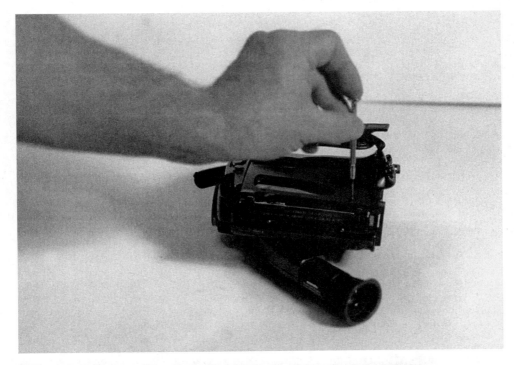

C.1. Unscrewing the door of the camcorder using a small screwdriver.

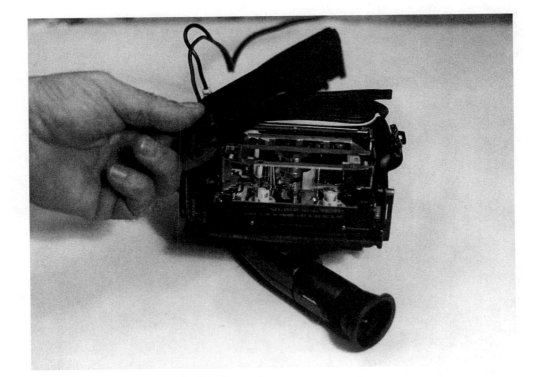

C.2. Removing the door of the camcorder.

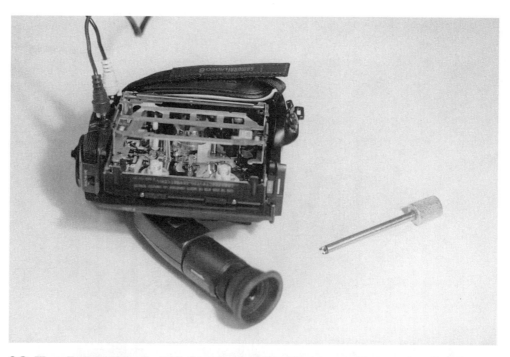

C.3. The alignment tool needed to perform the alignment. Notice also that a cable with RCA plugs is connected to the video and audio output jacks of the camcorder. This cable will connect to a composite video analog monitor.

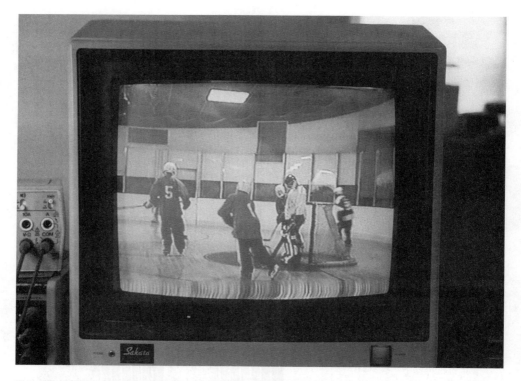

C.4. The video output of the camcorder displayed on the monitor. Notice the line at the bottom of the screen. This indicates an alignment problem.

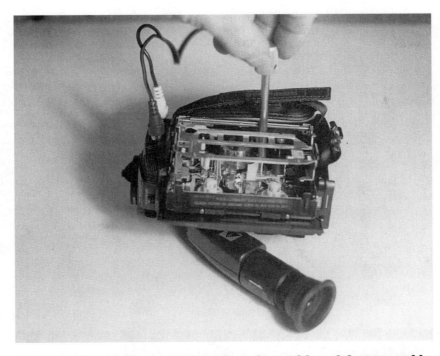

C.5. Using the alignment tool to adjust the position of the tape guide. This solved the problem, but we had to tighten a lock screw at the bottom of the guide. The only way to get to this screw is through further disassembly.

C.6. Unscrewing the lens cover.

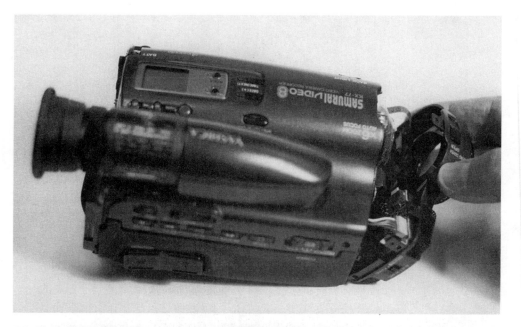

C.7. Removing the lens cover. Two cables connect the lens cover to the main body of the camcorder.

C.8. To remove the flat cable, you must push on the connector to release the tension.

C.9. This is the same connector in the closed position.

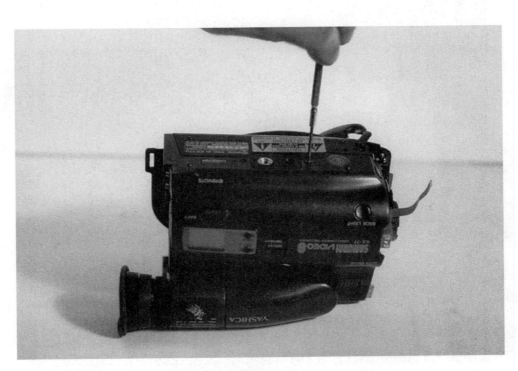

C.10. Unscrewing screws from the bottom of the camcorder.

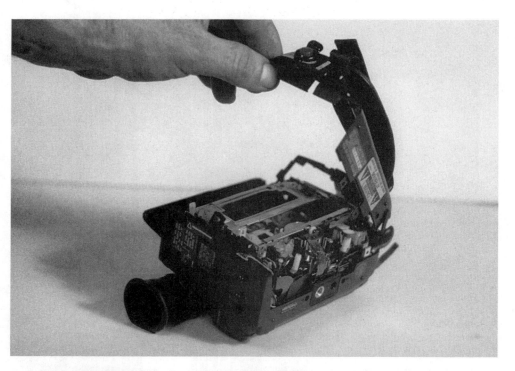

C.11. Removing the side cover of the camcorder to get at the tape guide screws.

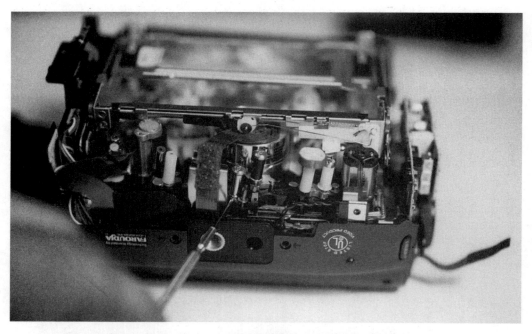

C.12. Tightening the lock screw of the tape guide that we had aligned.

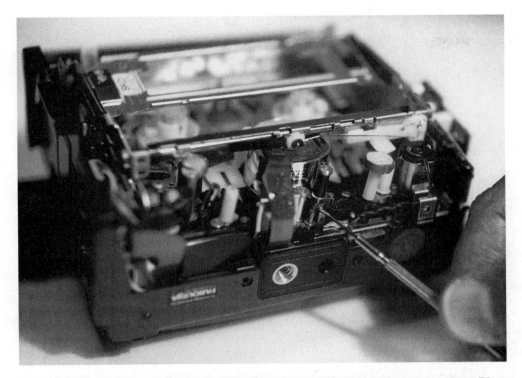

C.13. Tightening the lock screw of the other tape guide, just as a precaution. After this we reassembled the camcorder and tested it for proper operation.

Case Study 4:
Quasar QuarterBack VM500

The Quasar QuarterBack VM500 VHS-C camcorder had a shutoff problem. If you tried to record or play, the camcorder would shut off after a few seconds. This symptom can mean anything. For example, the camcorder might have a problem with the takeup reel, such as a slipping clutch, or possibly a defective sensor or mode switch, or maybe excessive tape tension on the video head.

We began the repair by unscrewing two screws from the door covering the cassette loading mechanism. Once we removed this cover we had access to the cassette mechanism. One of the ways to check the mechanism is to use a test jig, if you have one. Another way is to cover the LED mounted in the center of the machine with something black to block the light. Alternately, you can cover the end sensors with black tape. By deliberately defeating the sensors, you can activate play mode and watch the movement of the various parts.

We covered the LED with a small rubber tube and pressed the play button. The machine reacted by loading the imaginary tape. In other words, the takeup arms and tape posts moved up to their respective end positions and locked in place. The capstan shaft engaged the pinch roller, and the capstan motor started turning. We watched these movements closely and determined that all the parts were working fine.

We now placed a tape in the camcorder and checked to see how the machine behaved. The tape moved smoothly, with no bends or wrinkles. Everything seemed to work okay. Next, we checked the back tension of the tape. Excessive back tension can put a strain on the drum motor, which is very sensitive. The motor will go out of sync and ultimately the camcorder will shut off.

We checked the tape tension with a plastic rod; the tension seemed to be greater than normal. To make this test, you simply place the plastic rod against the tape during play mode. Position the rod on the inside of the tape, just before it moves onto the drum. Push on the tape to get a feel for the correct tension. We made our decision based on our experience working with camcorders and VCRs. There are tools that can be used for this purpose, but these are very expensive. If you want to develop a feel for the correct tension, you should make it a habit to check the tension on working camcorders and VCRs, even though you may be fixing a different problem.

This camcorder supplies back tension with a spring, which is connected to a tension band that wraps around the supply reel. The spring has three levels of adjustment. The spring may be placed on one of three square plastic pegs, which are at different heights. By moving the spring from peg to peg, you adjust the tension. As the machine gets older, the spring may have to be moved up or down a peg. If the spring is on the top or bottom peg and needs further adjustment, it may be necessary to cut the spring or do the opposite, stretch the spring, to get more or less tension. If you can't obtain the correct tension by moving the spring to another peg, you have to do something else.

In this case, the spring was already on the lowest peg (least tension), but still was providing too much tension. We decided to stretch the spring slightly to relieve the tension. To do this, we inserted a flat blade screwdriver in the top turn of the spring and applied enough pressure to stretch the spring. Stretching it relieved the pressure on the tension band, which as we said, wraps around the supply reel. Ultimately this translates into less pressure on the video head. Now, when we pressed play or record, the camcorder worked normally.

Why does a camcorder need back tension? All machines that use a tape as a storage medium need back tension. Otherwise, there is no pressure on the tape to contact the video head.

When there is too much tension, the tape may vibrate. On a video machine this may cause a jumpy unstable picture or distorted audio. In this case, the excessive back tension put too much of a load on the drum motor, which directly turns the video drum. On battery-operated equipment, this motor is not very powerful. Any excessive load will shut off the camcorder, protecting the rest of the circuitry that controls the motor.

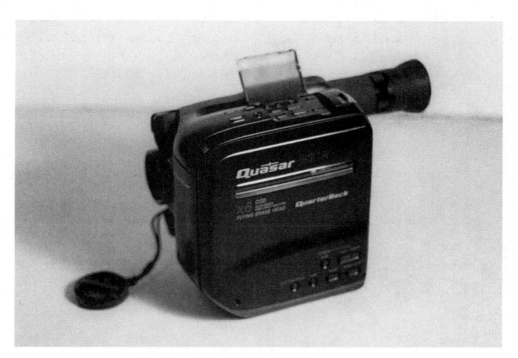

D.1. The Quasar QuarterBack VM500 VHS-C camcorder.

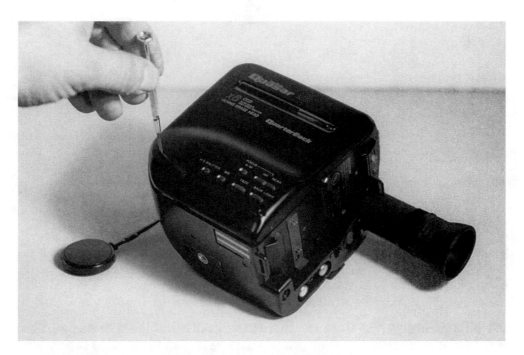

D.2. Unscrewing the door that covers the cassette housing.

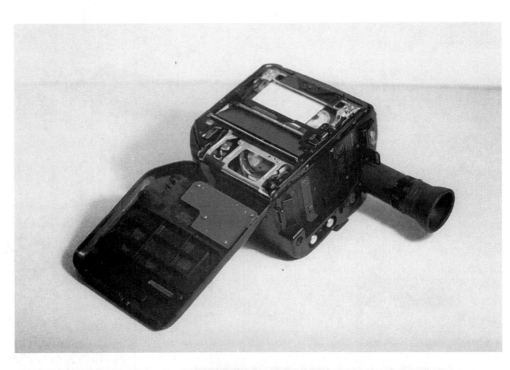

D.3. With the door opened, you have a perfect view of the cassette housing.

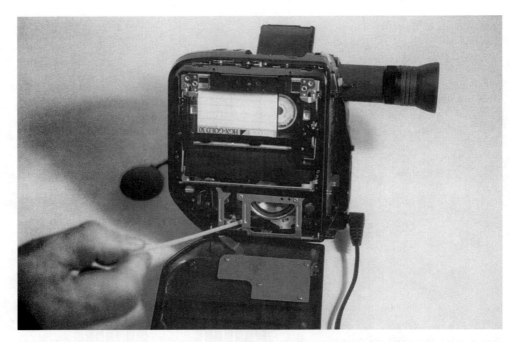

D.4. With the tape in play mode, we used a plastic rod to test the tape tension. This test demands experience, which you can gain by testing the tension in properly working camcorders and VCRs.

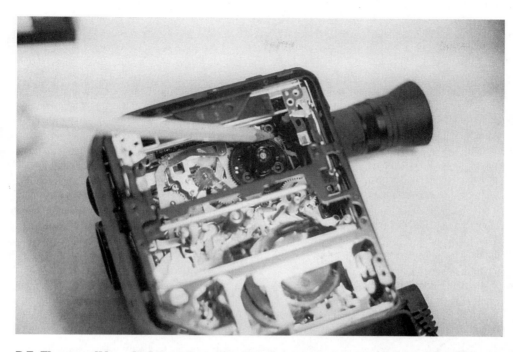

D.5. The pencil is pointing to the spring that provides the back tension to the supply reel.

D.6. The spring was already at the minimum tension position, so we stretched the spring slightly with a flat blade screwdriver to further lessen the tension. This solved the problem.

Appendix E

Case Study 5:
Sony Pro Model CCC-V9

This Sony 8 mm camcorder is an older model, purchased in 1989. The problem occurred when playing a tape—the picture in the viewfinder scrolled vertically. It made you wish there was a vertical hold adjustment on the camcorder. This problem, though, has nothing to do with vertical hold.

To verify the problem, we powered up the camcorder and connected the output to our video monitor. Sure enough, the picture was jumping. We checked the tape and noticed that it was chewed up on its edges. We substituted a test tape to see if the picture would improve but got the same results. We concluded that the problem was in the tape transport. In other words, this camcorder had a mechanical malfunction, possibly due to alignment, back tension or the pinch roller.

We removed the cover of the cassette housing and pressed play. We observed the tape movement, though there isn't much to see because the tape covers most of the mechanism. To check the back tension, we placed a plastic rod against the tape. The tape had no tension at all.

We removed the cassette and inspected the small tape post that supplies the back tension (it is connected to the band brake that goes around the supply reel). We noticed the tape post was moving back and forth, but with great difficulty. This is a typical problem in Sony camcorders and VCRs, too. The lubricant used when producing the product dries out over the years and becomes thick and gooey.

There are two ways to remedy this problem. The more complicated way is to remove the plastic clip securing the bracket that holds the tape guide and lift it upward. Then, you can clean the shaft and the bracket hole with alcohol and add new grease to the joint. But, this is complicated and you may run into trouble. There is a band brake attached to this bracket

and, once you remove it, you may damage it or break the plastic clips that hold the band brake in place.

We have discovered an easier way to deal with this problem. We dip the shaft of a very small screwdriver into a container of WD-40 oil. Then, we place one drop on the shaft directly over the plastic clip that holds the bracket in place. We repeat this process every five minutes or so until the oil penetrates the shaft. It very easy to tell when this happens because the bracket begins to move very easily. In this case, before we put the oil on the shaft, the bracket moved very slowly, even though it was being pulled by a spring. The bracket looked like it was moving in slow motion.

After the oil penetrated the shaft, the bracket moved freely and the spring pulled it back easily to its original position. The purpose of the spring is to put back tension on the tape through the band brake.

Once the oil took effect, we placed the tape back into the camcorder. We recorded some material and played it back. Now the picture was rock solid, not jumpy at. However, we could not save the material already recorded on the tape while the camcorder was defective.

As mentioned, this camcorder is an older 8 mm model. It gave the customer good service for many years. This particular problem is difficult to locate if you are not familiar with the mechanical operation of the camcorder. A camcorder is like any other VCR or cassette mechanism that uses a tape. The back tension is needed to supply contact between the video head and the tape.

Knowing what to do makes this a very simple repair. All we had to do was remove two screws from the camcorder door. No new parts were needed, only a few drops of oil.

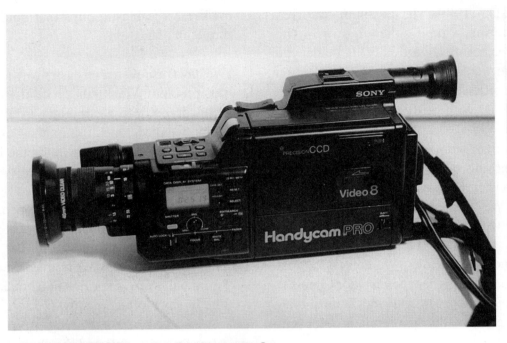

E.1. The Sony Handycam Pro 8 mm camcorder.

E.2. Unscrewing the door that covers the cassette housing.

E.3. Removing the door.

E.4. The lubricant on this shaft had become thick and gooey, retarding the movement of the bracket that controlled the back tension of the tape.

E.5. A closer look at the shaft, bracket and spring.

E.6. To solve the problem, we dipped a small screwdriver into WD-40 oil and let a drop of oil run down onto the shaft. We repeated this process every 5 minutes or so until the bracket began to move freely again.

Appendix F

Case Study 6:
RCA Model PRO843

The problem with this camcorder was that its play button was acting like a pause button. When you pressed play, one frame of video appeared on the viewfinder, then after a few seconds the camcorder shut off.

A glance through the window of the cassette door showed that the tape was not moving. To obtain a better view, we unscrewed the cassette door and lifted it off. Then we pressed play again. There was no doubt about it—the tape was not moving.

We figured the mechanism was jammed somehow, so we took the video cassette out of the camcorder and examined the camcorder gears, tape guides, pinch roller, and so forth. We didn't notice anything unusual, but at the same time, we didn't have a perfect view of all the moving parts. To get a better view, we unscrewed the part of the plastic case that covers the cassette mechanism and then removed the cassette housing assembly (the part that holds the cassette). Still, we could not spot the problem.

We decided to put the mechanism in motion. Before you do this, though, you must disconnect the loading motor from the main PC board. To do this, you simply disconnect the appropriate ribbon cable. If you neglect this step, you can easily blow out a motor driver IC. At this point, we were ready to apply power to the loading motor.

We energized the loading motor by applying 3 VDC from our bench-type regulated power supply. We clipped the leads of the power supply to the motor contacts. You do not have to worry about polarity. The motor turns one way or the other depending on how you place the leads on motor contacts. If the mechanism is going the wrong way, simply switch the leads.

When we applied power, the various parts of the mechanism moved to their "play" posi-

tions. At last, we noticed something. The pinch roller was not pressing against the shaft of the capstan. This was why there was no movement when we first tried to play a tape. In order for the tape to move, it must be pulled out of the cassette by the force of the pinch roller spinning against the capstan shaft. Now, we had to find out what was causing the problem. This entailed more disassembly.

We needed to completely remove the mechanism from the rest of the camcorder. We started by removing the microphone assembly. Next, we unscrewed three tiny screws that secured the metal chassis to the main PC board. Finally, we disconnected a ribbon cable that attaches to the sensors of the mechanism.

Now, we were able to lift the mechanism out of the camcorder and inspect it for any damage. In order for the pinch roller to engage the capstan shaft, the pinch roller has to be moved by a large cam gear with an integrated track. When the cam gear arrives at a certain point of its movement, it pushes the pinch roller firmly against the capstan shaft.

After closely inspecting all the gears of the assembly, we noticed that the plastic gear of the mode switch had two broken teeth. Thus, the whole assembly was out of alignment. This is why the pinch roller did not engage the capstan shaft. We ordered a new mode switch from Fox International.

To remove the broken mode switch, we first unscrewed it from the chassis. The mode switch has a long ribbon cable that is screwed and glued to the bottom of the chassis. We removed the screw and then pried off the ribbon cable. Finally, we removed the switch from the chassis.

When the new mode switch arrived, we peeled off the adhesive strip from the ribbon cable and pressed it in place on the chassis. At the

end of the ribbon cable is a small bracket that supports it firmly. The cable attaches to a connector on the main PC board.

With the ribbon cable in place, we maneuvered the gear of the mode switch into place between the main cam gear and tension cam gear. You would think that we were almost finished, just needing to reassemble the camcorder. But this could not be further from the truth. The fun was just beginning.

In order for the camcorder to work properly, you have to align all the gears. We tried to do it on our own but had no success. At this point, we realized we had to order the service manual. Thomson Consumer Electronics sells RCA service manuals. When the manual arrived, we followed the instructions for aligning the gears of the chassis.

Aligning the gears is a tedious process. You can't just lift up the gear to get it into its correct position. In fact, one of the gears of this camcorder is riveted to the chassis! If you place a screwdriver under this gear to lift it up, you will damage the rivet. Later on, the gear will skip and you will have to hammer the rivet back down. The proper way to align the gears is to find the ones that are held down by screws. Then, you can loosen the screw and raise the gear to set it to its proper position.

We aligned the gears according to the figures shown in the manual, which are shown together in Figure F.1. Then, we tested the alignment by applying 3 VDC to the loading motor. Again, you must always make sure that the plug that goes to the cassette loading motor is disconnected. If you don't do this, you may damage the IC that controls the motor.

After a few tries, we were certain the gears were correctly aligned. We reassembled most of the camcorder and had only to replace the cassette housing assembly to complete the job. But, this is another tricky task. Once this assembly is seated properly, you have to screw it down. Make sure to pay attention to the cassette housing eject latch on the bottom. This latch must be properly seated.

After we had all the parts in place, we tested the camcorder. Once again, we made sure the small plug that goes to the loading motor was disconnected. Then, we used 3 VDC from the power supply to energize the loading motor. We watched to see if all the gears meshed correctly. Everything seemed to be working properly, so we put the plug for the loading motor back in place.

We powered the camcorder and hit the eject button. We placed a tape into the machine and pressed play. The camcorder loaded the tape and started playing. Before we had time to enjoy the moment, the tape suddenly came flying out of the machine. We were baffled. We thought maybe the tape was bad and replaced it with a new one. The same thing happened.

After closely inspecting the video head assembly, we realized that the tape was sticking to the drum. Probably, during the repair, we inadvertently touched the video drum with our fingers, leaving a small residue of grease on the head. This is enough to cause the tape to stick to the drum. To fix this problem, we thoroughly cleaned all the parts of the tape path as well as the video head and drum assembly.

This cured the problem. Now, the camcorder worked properly. To finish up the job, we did a slight alignment of the right tape post. This gave us a perfect picture.

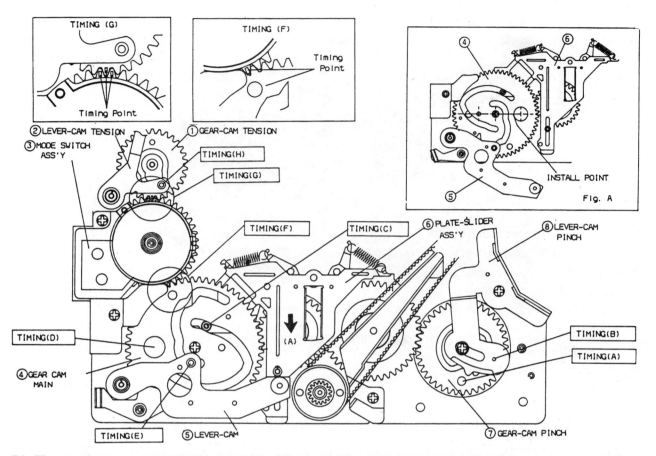

F.1. The service manual provides the information needed to properly align the gears of the camcorder.

Reproduced with the permission of Thompson Consumer Electronics.

F.2. The RCA Model PRO843 8 mm camcorder.

F.3. Unscrewing the case to get a better view of the cassette mechanism.

F.4. Removing one side of the case.

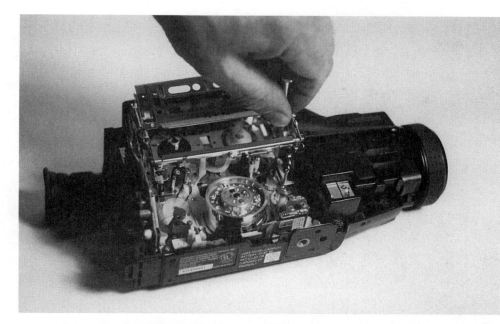

F.5. Using a small Phillips head screwdriver to remove the cassette housing assembly.

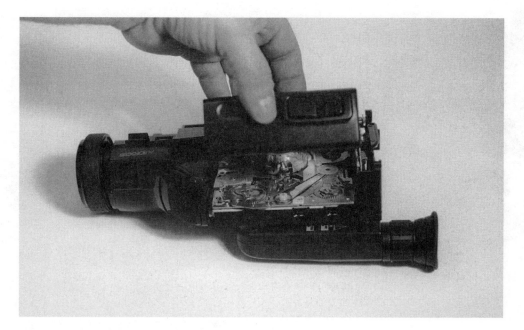

F.6. Lifting off the cassette housing assembly.

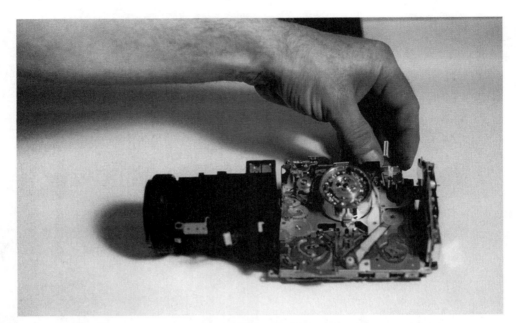

F.7. Unplugging the cable that goes to the loading motor. Forgetting to do this can blow out the motor driver IC.

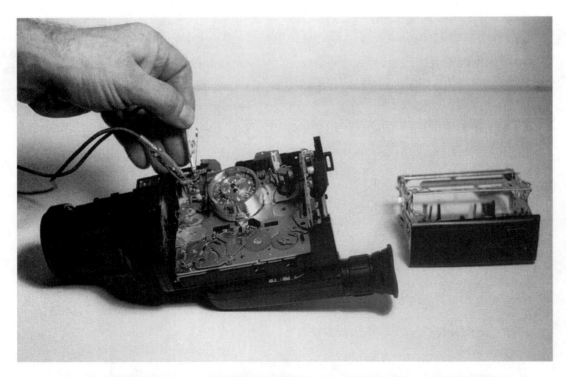

F.8. Applying 3 VDC from our bench power supply (not shown) to the loading motor.

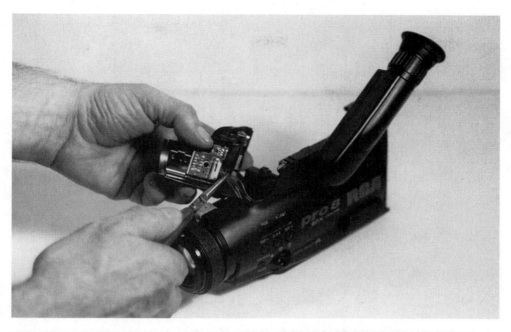

F.9. Further disassembly was needed, so we removed the microphone assembly.

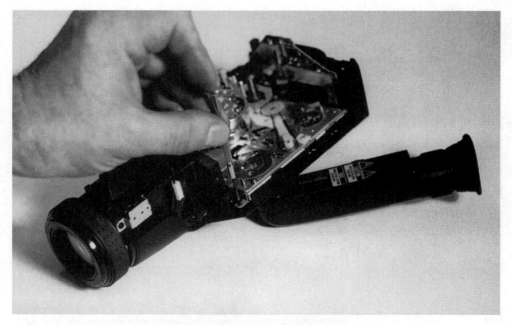

F.10. Unscrewing the mechanism from the main PC board.

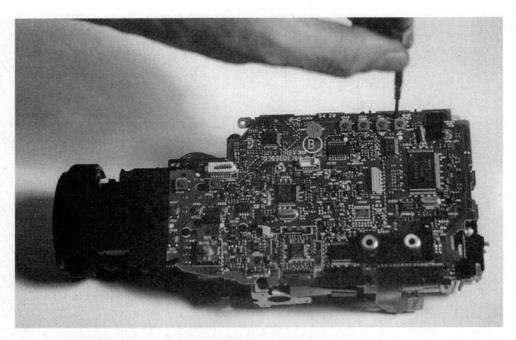

F.11. Unscrewing the main PC board from the mechanism.

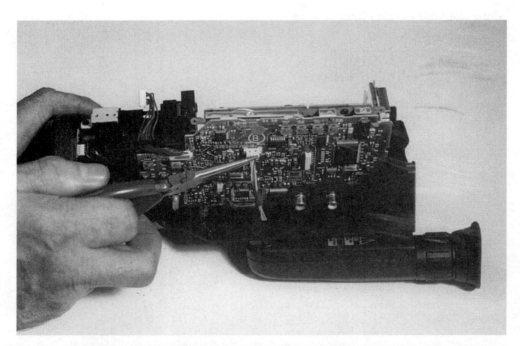

F.12. Unplugging a cable that connects the sensors on the chassis to the main PC board.

F.13. We noticed that the gear of the mode switch had two broken teeth. Notice the main cam gear below the switch and the tension cam gear above it.

F.14. Unscrewing the mode switch from the chassis.

F.15. Pulling the mode switch up from the chassis.

F.16. Unscrewing a metal bracket that holds down the mode switch cable.

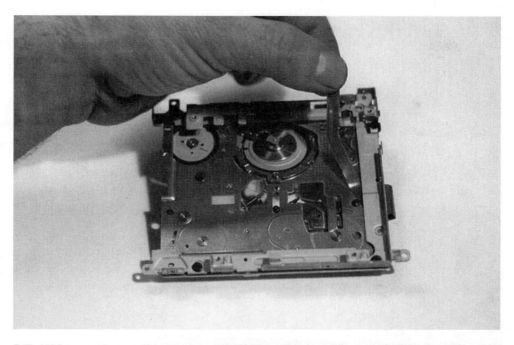

F.17. Lifting up the mode switch cable. This cable is glued to the chassis and has to be pried off.

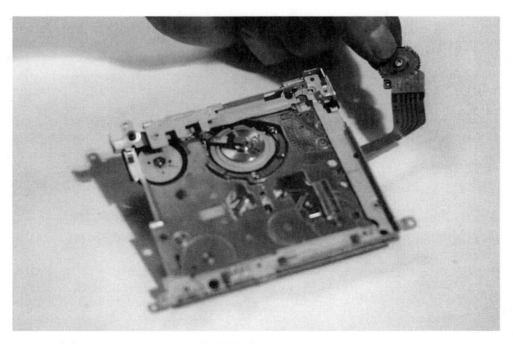

F.18. Pulling the mode switch assembly off the chassis.

F.19. One of the gears is riveted to the chassis. To properly align the gears, you have to loosen the screws of the other gears and position them as shown in the diagram of Figure F.1. After the alignment, we reassembled the camcorder and, after a couple of setbacks, got it back in working condition.

Appendix G
Case Study 7:
Hitachi VM-5000A

This full-size VHS camcorder would not play or record and sometimes had trouble ejecting a tape. With a tape in the machine, the camcorder produced a whirring noise if you pressed play or record and then, after a few seconds, shut off.

On this model, the loading motor is on the side of the cassette housing assembly, and the belt and pulley are visible when you eject a cassette. We pulled on the belt with a special curved tip tool. The belt felt loose. Probably, because the belt was loose, the loading motor was spinning and causing the whirring noise.

We unscrewed two screws on the cassette door and lifted it off. Each of these screws is hidden under a rubber cover, so you have to pry off the covers first. Next, we unscrewed the screws holding the sides of the case together. The left side, covering the main printed circuit board, comes off first, and then the right.

Now, we had a better view of the loading motor belt. We removed the belt with our curved tip tool and replaced it with a new one. This took a little time, since we had to squeeze the belt between the chassis and the pulley.

After we put the new belt on, we tested the camcorder's operation. Because the machine was disassembled, we powered it with 12 VDC from our bench supply. We placed the leads on the copper side of the PC board where the pins for the jack of the external supply were located.

We put a tape in and pressed play. The tape began to play—we saw the picture—but the takeup reel was not turning. So, the machine shut off. We took the tape out and replaced it with a test jig. The jig is transparent, so you can see how the mechanism is working. All parts of the cassette mechanism seemed to be operating except for the takeup reel.

We turned the camcorder over, unclipped the main PC board, and lifted it up. This gave us a perfect view of the bottom of the chassis. We pulled on the belt for the takeup reel. It was loose. Obviously, this machine had been laying around for quite some time, and the belts had lost their elasticity.

Replacing the takeup reel belt was more complicated than replacing the loading motor belt. We removed a plastic screw from the bracket that supports the capstan motor. Then, we loosened two other screws holding the bracket. This enabled us to lift the bracket and remove the belt. We put in a new belt and screwed down the bracket.

Now, when we tested the camcorder, the takeup reel turned and a picture appeared on the monitor. We did a slight adjustment of the tracking to obtain a perfect picture and then finished up the repair by reassembling the camcorder.

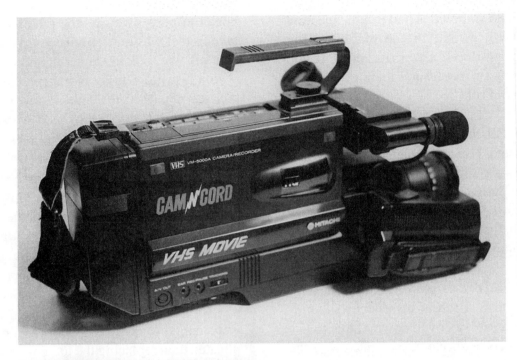

G.1. The Hitachi full-size VHS camcorder.

G.2. The screws for the cassette door were hidden under rubber covers.

G.3. Lifting off the cassette door.

G.4. Unscrewing one of many screws that hold the case together.

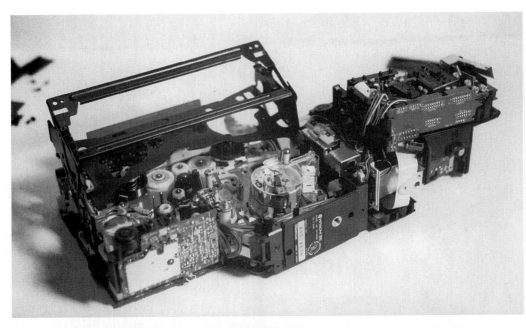

G.5. With the case removed, we had a perfect view of the cassette mechanism.

G.6. The loading belt is at the side of the cassette housing assembly.

G.7. We removed the loading belt with a special curved tip tool.

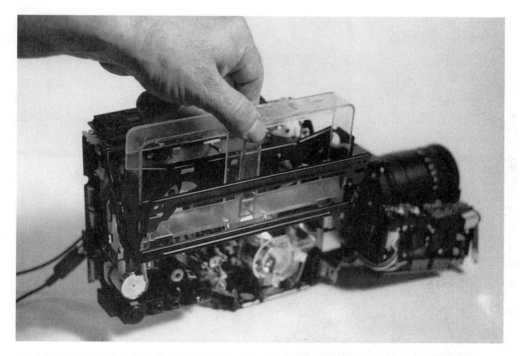

G.8. Replacing the loading belt did not solve the problem, so we powered up the unit with our bench supply and placed a test jig in the cassette holder.

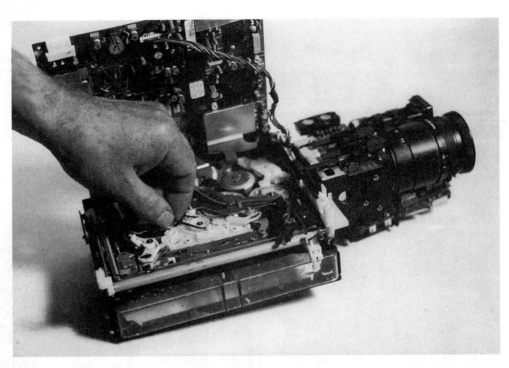

G.9. When we realized the takeup reel was not turning, we unlatched the main PC board, lifted it up, and inspected the underside of the cassette mechanism.

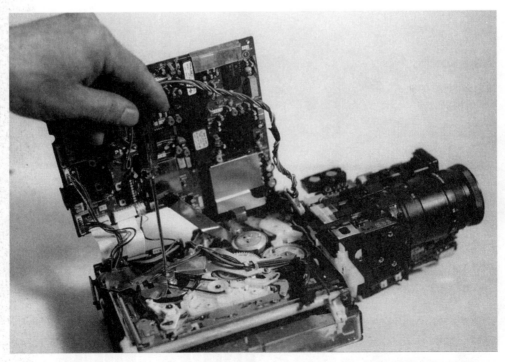

G.10. Unscrewing a plastic screw to facilitate the removal of the takeup reel belt. After we replaced this belt, the camcorder started working again.

Company Names and Addresses

Hitachi

Hitachi Home Electronics

675 Old Peachtree Rd.

Suwanee, GA 30174

JVC

JVC Service & Engineering Company of America

Divison of US JVC Corp.

107 Little Falls Road

Fairfield, NJ 07006

Minolta

Minolta Consumer Products

101 Williams Drive

Ramsey, NJ 07446

(201) 825-4000

Panasonic

Matsushita Services Company

50 Meadowlands Parkway

Secaucus, NJ 07094

RCA/GE

Thomson Consumer Electronics

RCA/GE Technical Publications

P.O. Box 1976

Indianapolis, IN 46206

Sharp

Sharp Electronics Corp.

P.O. Box 650

Sharp Plaza

Mahwah, NJ 07430-2135

Sony

Sony Electronics, Inc.

World Repair Parts Center

8281 N.W. 107th Terrace

Kansas City, MO 64153

1-800-488-7669

Index

Index

Dear Reader: *We'd like your views on the books we publish.*

PROMPT® Publications, a division of Howard W. Sams & Company (A Bell Atlantic Company), is dedicated to bringing you timely and authoritative documentation and information you can use. You can help us in our continuing effort to meet your information needs. Please take a few moments to answer the questions below. Your answers will help us serve you better in the future.

1. What is the title of the book you purchased?_____
2. Where do you usually buy books?_____
3. Where did you buy this book?_____
4. What did you like most about the book?_____
5. What did you like least?_____
6. Is there any other information you'd like included?_____
7. In what subject areas would you like us to publish more books? (Please check the boxes next to your fields of interest.)

❑ Audio Equipment Repair ❑ Home Appliance Repair

❑ Camcorder Repair ❑ Mobile Communications

❑ Computer Repair ❑ Security Systems

❑ Electronic Concepts Theory ❑ Sound System Installation

❑ Electronic Projects/Hobbies ❑ TV Repair

❑ Electronic Reference ❑ VCR Repair

8. Are there other subjects that you'd like to see books about? _____

9. Comments _____

• •

Name _____
Address _____
City _____ State/ZIP _____
E-Mail _____
Would you like a *FREE* PROMPT® Publications catalog? ❑Yes ❑ No
Thank you for helping us make our books better for all of our readers. Please drop this postage-paid card into the nearest mailbox.
For more information about PROMPT® Publications, see your authorized Howard Sams distributor or call 1-800-428-7267 for the name of your nearest PROMPT® Publications distributor.

PROMPT.
P U B L I C A T I O N S

A Division of *Howard W. Sams & Company*
A Bell Atlantic Company
2647 Waterfront Parkway, East Dr.
Indianapolis, IN 46214-2041

BUSINESS REPLY MAIL

FIRST-CLASS MAIL PERMIT NO. 1317 INDIANAPOLIS IN

POSTAGE WILL BE PAID BY ADDRESSEE

PROMPT
PUBLICATIONS®

A DIVISION OF HOWARD W SAMS & CO
2647 WATERFRONT PARKWAY EAST DRIVE
INDIANAPOLIS IN 46209-1418

NO POSTAGE
NECESSARY
IF MAILED
IN THE
UNITED STATES